IMAGES
of America

KEARNY

D1069345

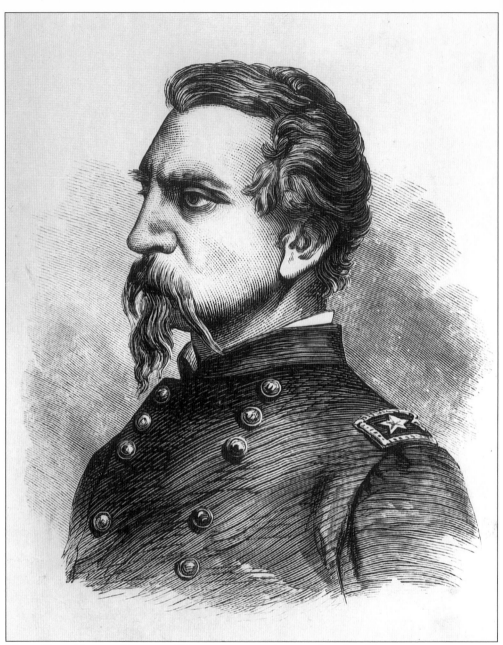

MAJ. GEN. PHILIP KEARNY. The town once known by the Native American name Mighgecticok was named after Maj. Gen. Philip Kearny in 1868. Born in New York City, Kearny received his law degree from Columbia University in 1833. Established as a war hero during the Mexican War, Kearny—the "One-Armed Devil"—was commander of the U.S. Army of the Potomac during the Civil War. Civil War historian Harrison Hunt called Kearny "probably the most colorful officer in the Union Army, and certainly one of its best fighters." Kearny was only 48 when he was shot to death at sunset in Chantilly, Virginia, on September 1, 1862. (Courtesy of AT&T Archives.)

IMAGES
of America
KEARNY

Barbara Krasner and the Kearny Museum

May 21, 2002

Enjoy this trip through historic Kearny!

Best,

Barbara Krasner

ARCADIA

Copyright © 2000 by Barbara Krasner and the Kearny Museum.
ISBN 0-7385-0403-3

First published 2000
Reprinted in 2001.

Published by Arcadia Publishing,
an imprint of Tempus Publishing, Inc.
2A Cumberland Street
Charleston, SC 29401

Printed in Great Britain.

Library of Congress Catalog Card Number: 99-069059

For all general information contact Arcadia Publishing at:
Telephone 843-853-2070
Fax 843-853-0044
E-Mail sales@arcadiapublishing.com

For customer service and orders:
Toll-Free 1-888-313-2665

Visit us on the internet at http://www.arcadiapublishing.com

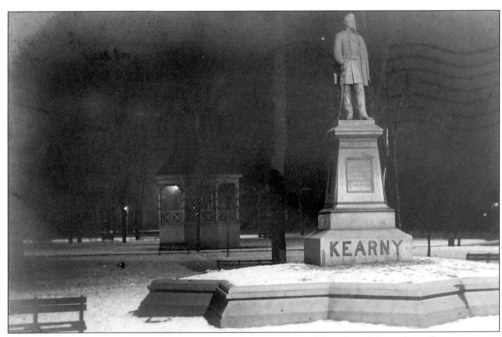

AN ABOUT-FACE. Kearny citizens were in an uproar in 1961 when Newark authorities reset the statue of Philip Kearny in Military Park with its back toward the town named for him. Mayor Joseph Healey and the Kearny Town Council issued a resolution to have the Civil War hero face east toward the town that was once his home and toward New York City where he was born. The resolution did not pass but as a compromise, the town of Kearny received a copy of the statue, which now stands in front of the post office on Midland Avenue.

CONTENTS

Acknowledgments 6

Introduction 7

1. Beginnings 9

2. Civic and National Pride 13

3. Local Business 37

4. An Industrial Mecca 55

5. At the Crossroads 67

6. Keeping the Faith 75

7. School Spirit 85

8. Around Town 105

ACKNOWLEDGMENTS

I owe a debt of gratitude to Charlie Waller, director of the Kearny Museum, and George Rogers, who not only made the holdings of the museum available to this project, but also lent their vivid memories of the town. I remain in awe of what they know. I also must thank Craig Stewart, Norman Prestup, Mrs. and Mrs. Herman Gauch, and Robert McFadden for their extreme generosity in donating and lending photographs, postcards, histories, and other materials for the book. Some other individuals submitted a few items from their personal collections, and I thank them as well: Clavin Fisher, Frank Nicolle, and Henry Parks. Thanks also go to Nancy Smith of the Kearny Free Public Library, who gave me access to the many resources of the Kearny Room.

Though I never met her, I would like to express appreciation to the late Jessie Hipp for her tireless efforts as town historian. She had written and organized much of the town's history, particularly throughout its centennial period.

I would like to acknowledge Irene Lewecki of the AT&T Archives and Bunny White of the Lucent Archives for giving me access to photographs of the Western Electric Company's Kearny Works. Also, Joe Settani, archivist of the Jewish Historical Society of Metrowest, helped me find images of the town's Jewish community to complete the "Keeping the Faith" section.

Acknowledgment sources are noted in each caption.

Finally, I would like to thank my son, Matt, for graciously allowing me the time away from him to work on this, and my late father, Milton Krasner, for teaching his daughters to pursue their dreams.

INTRODUCTION

Once called the City of Opportunity, the area known as Kearny has been at the crossroads of history, transportation, and commerce for the last 330 years.

Kearny began as a piece of property known to the Native Americans by the name of Mighgecticok that was sold by Chief Tantaqua of the Lenni-Lenape Indians to Capt. William Sandford of Barbadoes in 1668. The 9.33-square-mile area was wedged between the Pasawack (now Passaic) and Hackensack Rivers. In 1710, the area was called New Barbadoes Neck.

Arent Schuyler purchased the Kingsland plantation in New Barbadoes and selected the most attractive spot on the plantation for the Schuyler family residence. It was called Fairlawn Manor and occupied the area just below Pleasant Place, bounded by the Belleville Turnpike. One of Schuyler's slaves, as the story goes, discovered copper, and the mining began.

The discovery of copper brought the first steam engine to America. Josiah Hornblower, engineer of the steam engine, hauled it from the Passaic River along what became the Belleville Turnpike. The road was built by John Schuyler, second son of Arent Schuyler, to transport his copper ore to the Hackensack River. John Schuyler was also one of George Washington's generals.

In 1825, the name New Barbadoes Neck was changed to Lodi and in 1840, it was again changed to Harrison to honor then Pres. William Henry Harrison. Through the efforts of Gen. Nathaniel Halstead, a friend of the late town resident Maj. Gen. Philip Kearny, the township became known as Kearny in 1867 and through its incorporation 30 years later, became the Town of Kearny.

The northern section of town was called the borough of Arlington by the Arlington Homestead Association, which formed in 1867 to develop the section. This part of town was named after Arlington Heights, Virginia, because of its elevation—said to be the highest in Hudson County at the corner of Midland Avenue and Belgrove Drive. Arlington, mostly residential, included the famous Passaic riverfront estates.

Situated between the metropolitan centers of Newark and Jersey City, Kearny has benefited from access to major roadways, waterways, and railroads, making it an attractive and prosperous location for industry and commerce. Immigrants from the British Isles arrived to work at the textile and floor-covering mills and plants and brought with them a heritage still evident in the town today. In 1875, the Clark Thread Mills of Scotland opened a factory here, followed by Marshall's Flax Spinning Company from England in 1883. Sir Michael Nairn established Nairn Linoleum in 1888, which brought and employed more Scottish families in the floor-covering

industry.

Perhaps surprising to today's residents, the "downtown" area was not Newark but the east side of Midland Avenue and its intersecting streets, offering shops, real estate offices, banks, and the Arlington Depot.

The town has also had its share of celebrity appearances: Gen. John J. Pershing participated in the 1922 dedication of the World War I monument, which was welcomed by some 25,000 people; Hollywood stars Paulette Goddard and William Gargan arrived to sell war bonds; actress Ruby Dee once worked at the Western Electric Company's Kearny Works; Pres. William Taft personally presented a shell from the USS *Maine* to Kearny resident and Civil War veteran Alfred King, who pushed Congress to raise the ship; and George Washington stayed at the Schuyler Mansion. Let us not forget that Kearny spawned professional players for the New York Giants, the Detroit Tigers, and the 1994 World Cup U.S. soccer team. Most recently, Kearny served as the filming location of Home Box Office's popular series *The Sopranos*.

Developed in conjunction with the Kearny Museum, this book focuses primarily on the late-19th and early-20th centuries. It offers you images of this historically rich town and invites you on a journey through the town: its beginnings, its demonstrations of civic and national pride, its local businesses, its industrial contributions, its transportation, its places of worship, its places of learning, and its streets, people, and homes.

For the first time, the vast holdings of the Kearny Museum, the AT&T Archives, and personal postcard and photograph collections are accessible to all. Inside you will find Kearny's Scottish heritage in kilt-clad bagpipe bands, the New Jersey Home for Disabled Soldiers built to house Civil War veterans, Schuyler Avenue dairy farms, the "oilcan" tower that once graced the Kearney Town Hall, the Belle Grove and Fairlawn Manor estates of General Kearny and the Schuyler family, the grand avenues of picturesque Arlington, and the titans of industry who produced thousands of local jobs and significantly helped the war effort during the 1940s by building ships, tools, and communications equipment—Federal Shipbuilding and Dry Dock, Standard Tool & Manufacturing, and Western Electric's Kearny Works all received the Army-Navy E during World War II.

We are fortunate that for years there has been a Kearny Museum and Historical Association. The museum really took shape during Kearny's centennial, but much work remains to be done to properly archive and preserve our precious history. Therefore, all royalties from this book are donated to the Kearny Museum.

One
BEGINNINGS

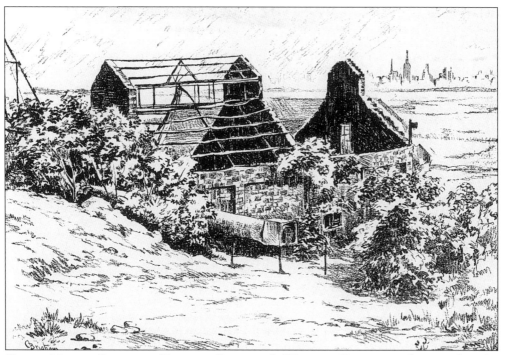

COPPER MINING OPENS THE ROAD TO SCHUYLER'S WEALTH. Green stone discovered on the Schuyler property contained 85% pure copper. The mines were destroyed by fire in 1772 and remained unused for several years; subsequently, thousands of tons of ore were mined. (Courtesy of the Kearny Museum.)

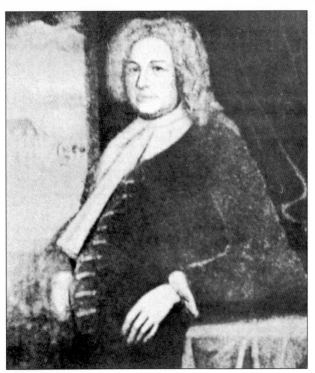

ARENT SCHUYLER. Arent Schuyler (1662–1730), a former Dutch trader and Native American agent, bought what is now Kearny, North Arlington, Lyndhurst, and Kingsland from Maj. Nathaniel Kingsland in 1710 for 300 English pounds. (Courtesy of Robert McFadden.)

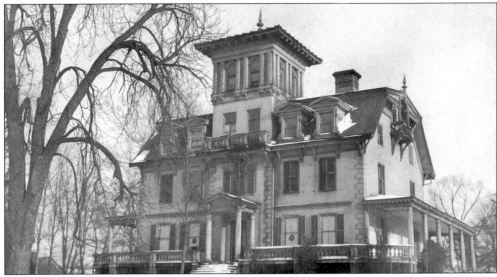

THE SCHUYLER MANSION, FAIRLAWN MANOR. On a spot bounded by the Passaic River and what is now the Belleville Turnpike was gently rolling, heavily wooded ground—the perfect place for the 1719 construction of the Schuyler manor house. Constructed of stone and bricks imported from Holland, the mansion stood as a source of pride until 1924. When the mansion was about to be torn down, a development company offered to deed a section of the 60 acres to any historical society that would pay for the upkeep. Despite wishes to preserve Fairlawn as a historic landmark (especially since it was hailed as one of Gen. George Washington's headquarters), no one was able to do so and this monument was destroyed. (Courtesy of the Kearny Free Public Library.)

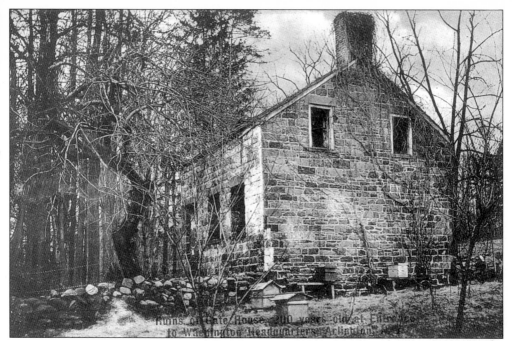

THE RUINS OF THE GATE HOUSE. Said to have been where Arent Schuyler lived during the erection of his home Fairlawn Manor, this gate house, shown as ruins, was built in 1710.

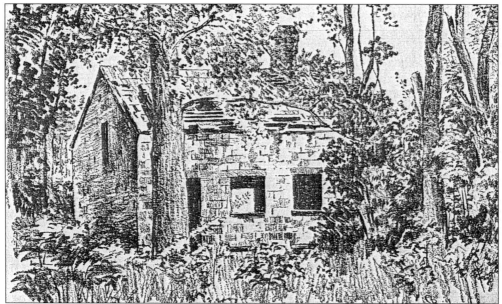

A SLAVE CABIN. While several slave cabins accompanied Schuyler's large manor home on the bluff overlooking the Passaic River in what is now the Fairlawn Manor section, this particular one was reputedly home to the slave who discovered the copper mine. According to a dubious story published in 1933, Schuyler told the slave that he could have three wishes as reward for his discovery. The slave's first wish was to be allowed to remain in Schuyler's service always, the second was for enough tobacco to last the rest of his life, and the third was for a frock coat with brass buttons just like the one his master wore.

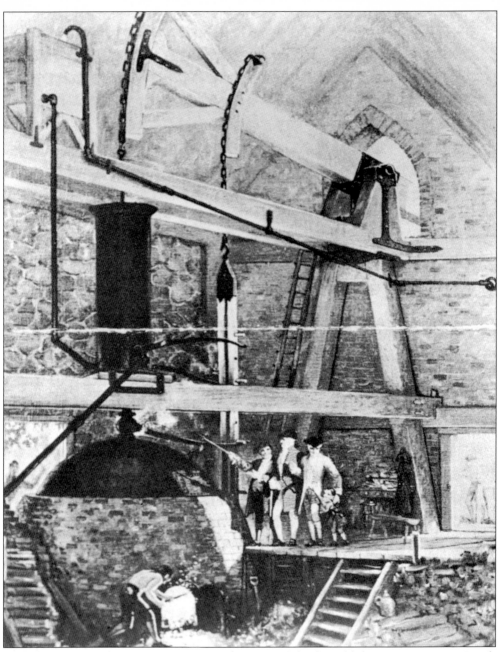

AN INTERIOR VIEW OF A COPPER MINE. John Arent Schuyler sold the copper mines to Josiah Hornblower in 1761, but a fire in 1768 put a stop to mining operations. It was not until 1792 that Philip A. Schuyler, a grandson of Arent Schuyler, convinced Hornblower to reopen the mines. Hornblower is shown here with members of the Schuyler family inside a copper mine. (Courtesy of Robert McFadden.)

Two

CIVIC AND
NATIONAL PRIDE

KEARNY'S SECOND TOWN HALL, BUILT IN THE EARLY 1870S. The rambling frame structure at Kearny and Woodland Avenues served as a combination town hall, schoolhouse, and courthouse. It continued as the town hall until 1909 when municipal business required larger quarters and the new town hall was built. To the right was the first firehouse south of Quincy Avenue, Kearny Firehouse No. 2, erected in 1887. Later, the Knox Presbyterian Church purchased the property. (Courtesy of the Kearny Museum.)

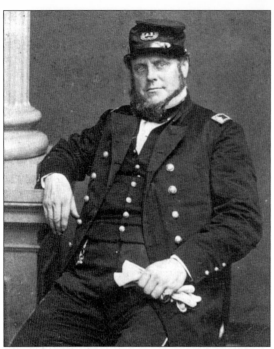

CHAIRMAN OF THE BOARD. A friend of Philip Kearny, Gen. Nathaniel Norris Halstead (1816–1884) led the way to the town's incorporation and the adoption of the name Kearny in 1867. Halstead, who owned the 40-acre showplace estate Hillside on the bank of the Passaic, served as the first "chairman" of the town. (From the Collections of the New Jersey Historical Society, Newark, New Jersey.)

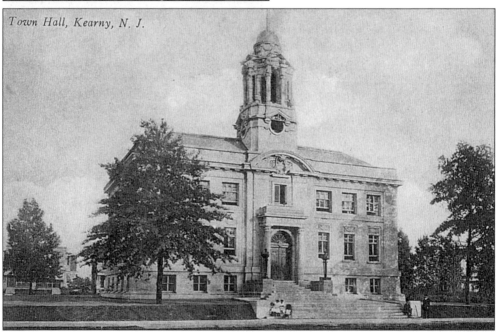

Town Hall, Kearny, N. J.

THE KEARNY TOWN HALL MOVES TO THE MIDDLE OF TOWN. Built in 1909 of Indiana limestone by the Davidson Brothers, the Kearny Town Hall was logistically situated in the middle of town on Kearny Avenue at Grove Street. It was originally constructed with a tall spire known as the oilcan. In 1914, the spire was hit by lightning, which damaged it beyond repair. Thus, the oilcan was removed. When this happened, Mayor Louis Brock, Town Clerk William Ross, and fire alarm supervisor George Smack were standing in the garret. Though unharmed, they were so stunned they were unable to move. (Courtesy of Norman Prestup.)

GOLDBERG, KEARNY'S FIRST MAYOR.
Surgeon and pharmacist Eugene H.
Goldberg was officially named mayor
when he took office in 1903; other titles
had included chairman of the board and
councilman at large. Born in New York
in 1868, he was in office from 1903
until 1907. He died in 1932 at his home
on Hillcrest Road. (Courtesy of the
Kearny Museum.)

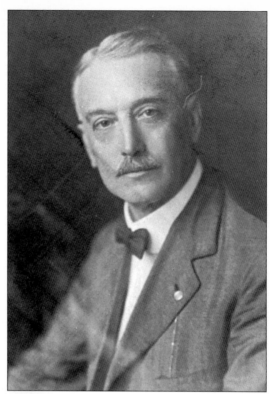

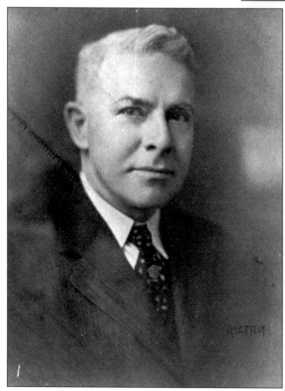

**FROBISHER, KEARNY'S SEVENTH
MAYOR.** Joseph E. Frobisher served
briefly as mayor from 1938 to 1939; he
died in 1939 at the age of about 67.
(Courtesy of the Kearny Museum.)

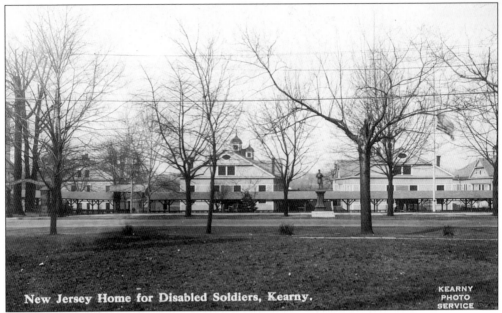

New Jersey Home for Disabled Soldiers, Kearny.

KEARNY
PHOTO
SERVICE

THE OLD SOLDIERS HOME: A KEARNY LANDMARK. In 1888, the New Jersey Home for Disabled Soldiers found a new 15-acre home on the east side of the Passaic River on Belgrove Drive, north of Bergen Avenue, formerly a portion of Joseph Huge's estate. Intended mainly for Civil War veterans, the home eventually became a haven for Spanish-American War and WWI veterans as well. The entrance was on the west side of Belgrove Drive, seen here on the left. There were 17 buildings, most of which were located on the west side. The superintendent's home and a carriage house were located on the east side of Belgrove Drive. (Courtesy of the Kearny Museum.)

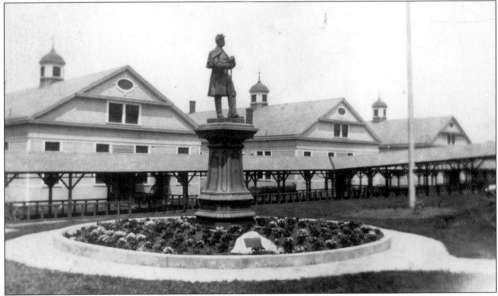

THE CIVIL WAR SOLDIER MEMORIAL CIRCLE, 1924. Bench-lined covered walkways to the barracks grace the Civil War Soldier Memorial Circle at the Old Soldiers Home. (Courtesy of the Kearny Museum.)

16

A RIVERFRONT VIEW. Barracks facing the Passaic provide residents of the Old Soldiers Home with a pleasant outlook. In June 1932, the 46 residents of the barracks, including 13 Civil War veterans, were relocated in a consolidated facility in Menlo Park and these buildings were demolished. Veteran's Field, appropriately named, now stands in their stead. (Courtesy of the Kearny Museum.)

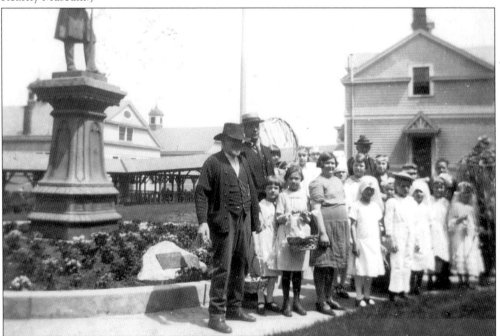

WHERE THE YOUNG MEET THE OLD. May walkers pose with Abraham Larue, a Civil War veteran, and John Nawrath, a regular army veteran, of the Old Soldiers Home in 1927. (Courtesy of the Kearny Museum.)

17

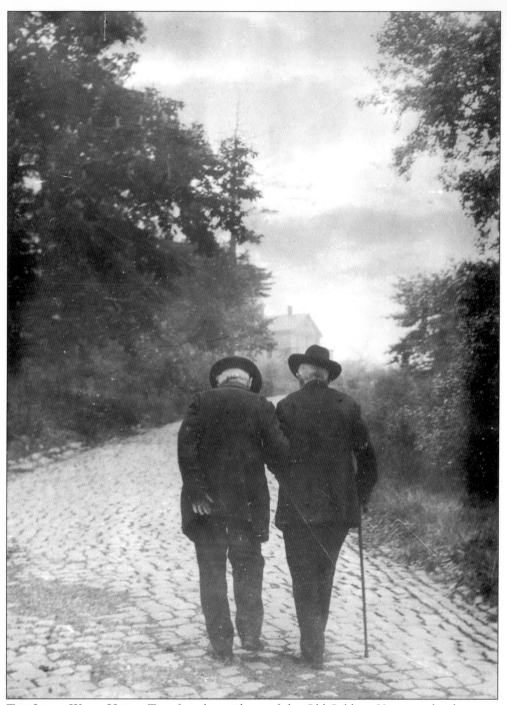

THE LONG WALK HOME. Two friends, residents of the Old Soldiers Home, make their way back to the barracks. (Courtesy of the Kearny Museum.)

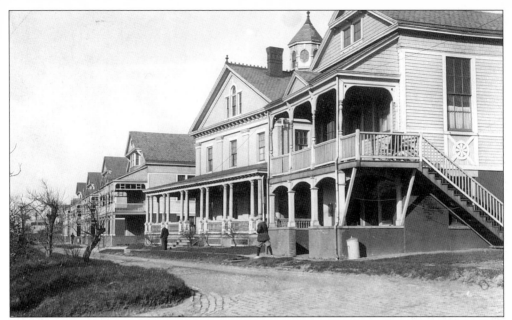

AN INSIDE ROAD WINDS THROUGH THE GROUNDS AT THE OLD SOLDIERS HOME. This inside road within the property paralleled Belgrove Drive and shows the soldiers' barracks. (Courtesy of the Kearny Museum.)

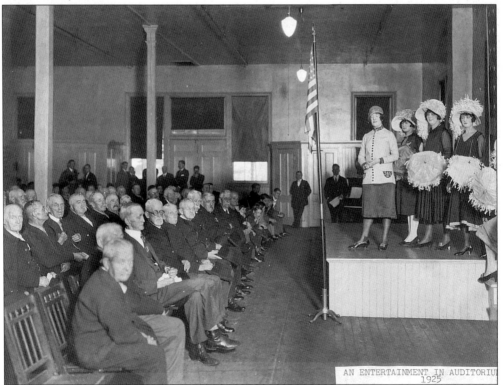

AN ENTERTAINMENT IN AUDITORIUM
1925

LET US ENTERTAIN YOU, 1925. Residents enjoy theatrical entertainment in the auditorium of the Old Soldiers Home. (Courtesy of the Kearny Museum.)

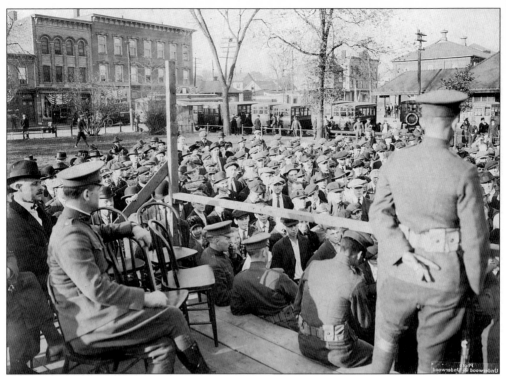

AMERICA GOES TO WAR, 1917. Throngs of eager Kearny men participate in this enlistment drive at the Arlington Depot. (Courtesy of the Kearny Museum.)

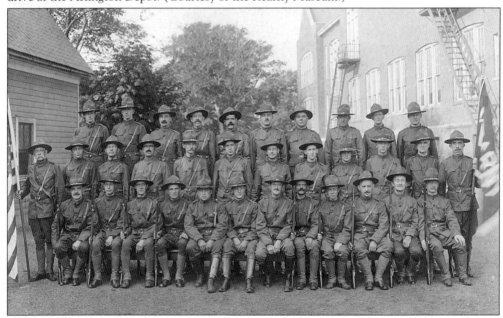

THE KEARNY HOME GUARD. A familiar local scene during WWI was the drilling of the Kearny Home Guard, which mobilized in May 1917. Company B of Kearny, under the command of Captain Castroupt, is featured here. Note the Lincoln School on the right. (Courtesy of the Kearny Museum.)

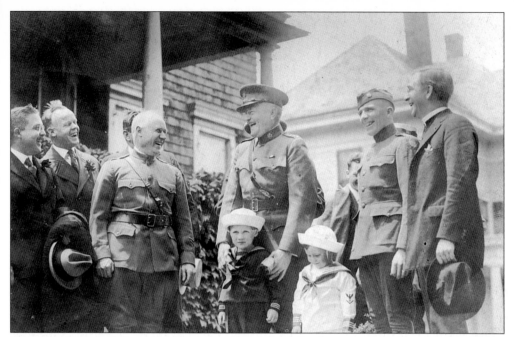

GENERAL PERSHING INVADES KEARNY. Gen. John J. Pershing, commander of the American forces in France in WWI, was on hand to dedicate Kearny's WWI monument in Memorial Park at the intersection of Kearny Avenue and Beech Street. He is shown here with friend and Kearny resident Maj. Gerrish Newell. (Courtesy of the Kearny Museum.)

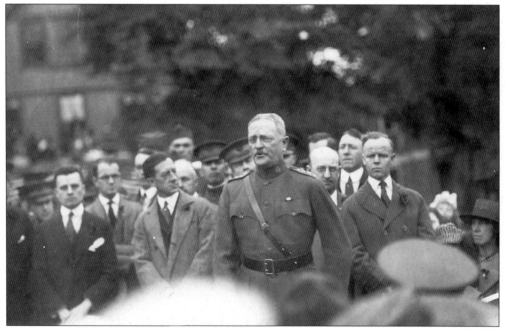

A ROSE BY ANY OTHER NAME IS PERSHING. Gen. John J. Pershing's participation in the dedication ceremonies had such an impact that many townspeople named their children Pershing. Here, Pershing is shown in the garden of the Gerrish Newell residence on Seeley Avenue. (Courtesy of the Kearny Free Public Library.)

THE WWI MONUMENT IN MEMORIAL PARK.
In the grassy section that bridges Kearny
Avenue and Beech Street just north of
Quincy Avenue stands this monument. Made
of Vermont granite, it bears the names of the
Kearny men who gave their lives in the Great
War. (Courtesy of the Kearny Museum.)

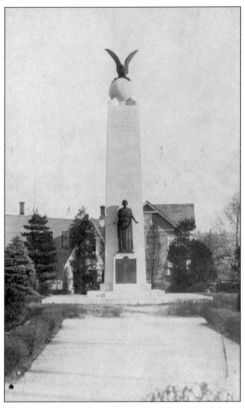

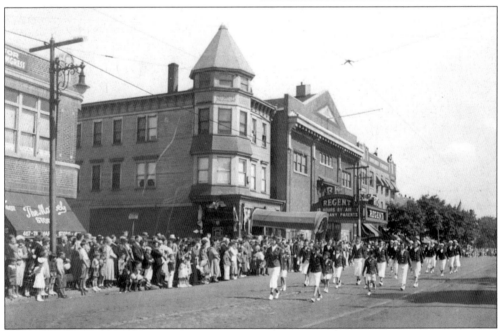

THE WWI MEMORIAL PARADE MARCHING ALONG KEARNY AVENUE. Some 25,000 people
lined the streets to watch 5,000 participants march in the May 1922 parade that accompanied
the monument's dedication ceremony. (Courtesy of the Kearny Museum.)

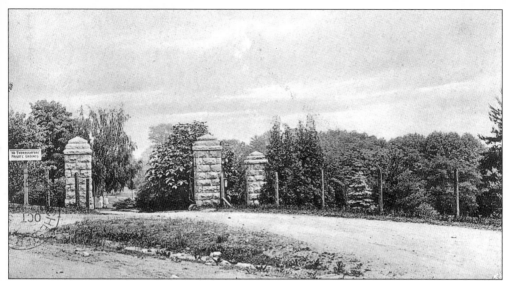

THE ENTRANCE TO THE ARLINGTON CEMETERY. Along Schuyler Avenue, between the Belleville Turnpike and Stewart Avenue, lies the Arlington Cemetery. First constructed in the 1880s, it was the first cemetery in the state to have landscaped lawns and to provide perpetual care. (Courtesy of Craig Stewart.)

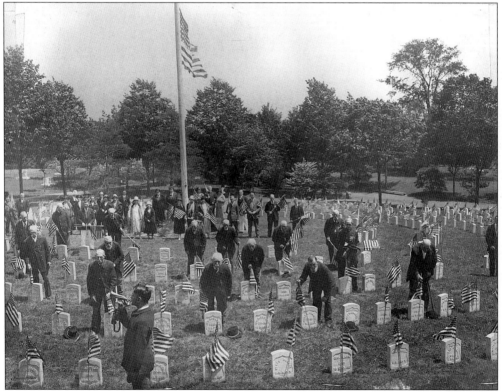

SOLDIER'S PLOT, ARLINGTON CEMETERY, 1926. Residents of the Old Soldiers' Home decorate the graves of their fallen comrades in Arlington Cemetery's "Veterans' Circle." The bugler in front plays "Taps." (Courtesy of the Kearny Museum.)

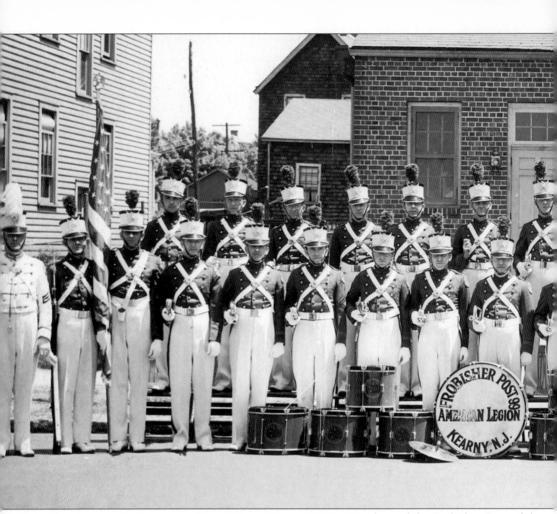

THE JOSEPH E. FROBISHER POST 99, C. EARLY 1930S. Members of the Frobisher Post of the American Legion stand in front of the post on Belgrove Drive. The post was instrumental in raising funds for the WWI monument by directing a house-to-house campaign. The post was

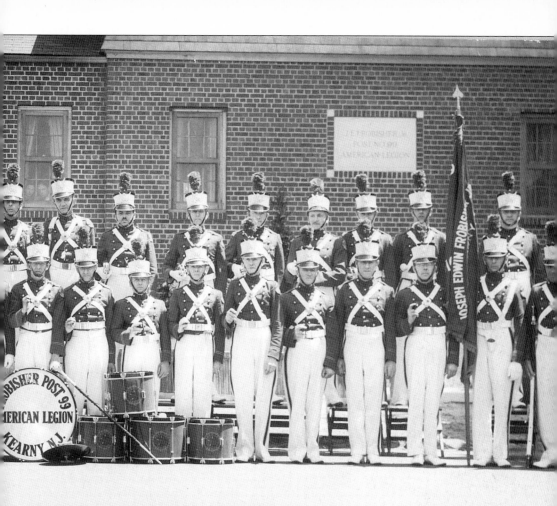

named for Joseph Edwin Frobisher Jr., who was killed in action in France in 1918. Frobisher was the son of prominent Kearny citizen and eventual mayor Joseph E. Frobisher. (Courtesy of George Rogers.)

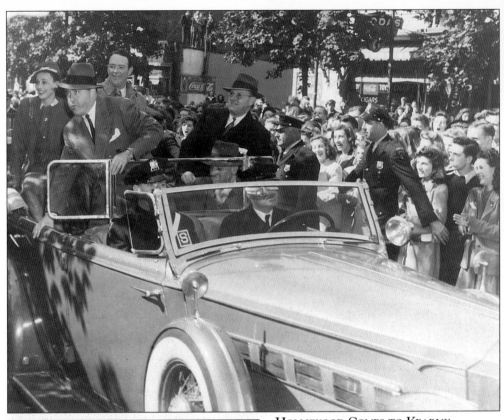

HOLLYWOOD COMES TO KEARNY. Hollywood movie stars Paulette Goddard and William Gargan draw a crowd as they arrive at the Kearny Town Hall to sell war bonds in the early 1940s. (Courtesy of George Rogers.)

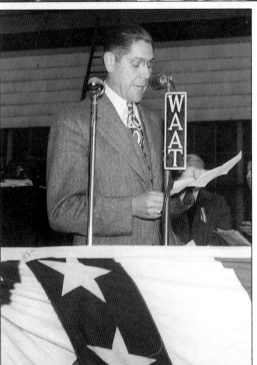

KEARNY MAYOR FREDERICK T. LAW DELIVERING A RADIO ADDRESS. Law served as the town's chief official from 1939 to 1943. (Courtesy of the Kearny Museum.)

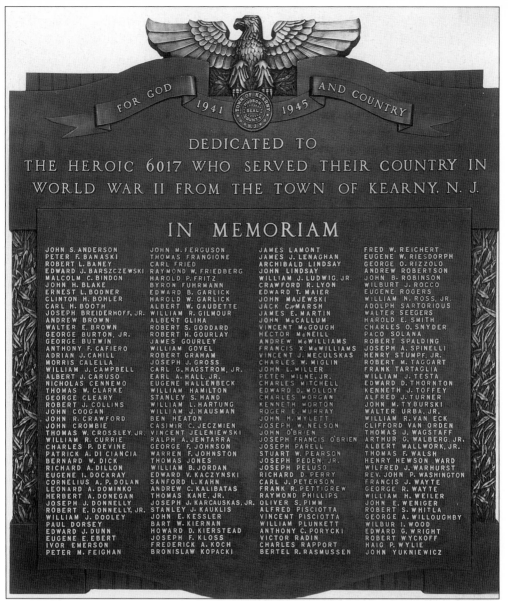

FOR GOD 1941 1945 AND COUNTRY

DEDICATED TO
THE HEROIC 6017 WHO SERVED THEIR COUNTRY IN
WORLD WAR II FROM THE TOWN OF KEARNY, N. J.

IN MEMORIAM

JOHN S. ANDERSON	JOHN M. FERGUSON	JAMES LAMONT	FRED W. REICHERT
PETER F. BANASKI	THOMAS FRANGIONE	JAMES J. LENAGHAN	EUGENE W. RIESDORPH
ROBERT L. BANEY	CARL FRIED	ARCHIBALD LINDSAY	GEORGE O. RIZZOLO
EDWARD J. BARSZCZEWSKI	RAYMOND W. FRIEDBERG	JOHN LINDSAY	ANDREW ROBERTSON
MALCOLM C. BINDON	HAROLD P. FRITZ	WILLIAM J. LUDWIG, JR.	JOHN B. ROBINSON
JOHN H. BLAKE	BYRON FUHRMANN	CRAWFORD R. LYON	WILBURT J. ROCCO
ERNEST L. BODNER	EDWARD B. GARLICK	EDWARD T. MAIER	EUGENE ROGERS
CLINTON H. BOHLER	HAROLD W. GARLICK	JOHN MAJEWSKI	WILLIAM N. ROSS, JR.
CARL H. BOOTH	ALBERT W. GAUDETTE	JACK C. MARSH	ADOLPH SARTORIOUS
JOSEPH BREIDERHOFF, JR.	WILLIAM R. GILMOUR	JAMES E. MARTIN	WALTER SEEGERS
ANDREW BROWN	ALBERT GLIHA	JOHN McCALLUM	HAROLD E. SMITH
WALTER E. BROWN	ROBERT S. GODDARD	VINCENT McGOUGH	CHARLES O. SNYDER
GEORGE BURTON, JR.	ROBERT H. GOURLAY	HECTOR McNEILL	PACO SOLANA
GEORGE BUTWIN	JAMES GOURLEY	ANDREW McWILLIAMS	ROBERT SPALDING
ANTHONY F. CAFIERO	WILLIAM GOVEL	FRANCIS X. McWILLIAMS	JOSEPH A. SPINELLI
ADRIAN J. CAHILL	ROBERT GRAHAM	VINCENT J. MECULSKAS	HENRY STUMPF, JR.
MORRIS CALELLA	JOSEPH J. GROSS	CHARLES W. MIGLIN	ROBERT M. TAGGART
WILLIAM J. CAMPBELL	CARL G. HAGSTROM, JR.	JOHN L. MILLER	FRANK TARTAGLIA
ALBERT J. CARUSO	EARL A. HALL, JR.	PETER MILNE, JR.	WILLIAM J. TESTA
NICHOLAS CENNEMO	EUGENE HALLENBECK	CHARLES MITCHELL	EDWARD D. THORNTON
THOMAS W. CLARKE	WILLIAM HAMILTON	EDWARD D. MOLLOY	KENNETH J. TOFFEY
GEORGE CLEARY	STANLEY S. HAND	CHARLES MORGAN	ALFRED J. TURNER
ROBERT J. COLLINS	WILLIAM L. HARTUNG	KENNETH MORTON	JOHN M. TYBURSKI
JOHN COOGAN	WILLIAM J. HAUSMAN	ROGER E. MURRAY	WALTER URBA, JR.
JOHN R. CRAWFORD	BEN HEATON	JOHN H. MYLETT	WILLIAM R. VAN ECK
JOHN CROMBIE	CASIMIR C. JECZMIEN	JOSEPH W. NELSON	CLIFFORD VAN ORDEN
THOMAS W. CROSSLEY, JR.	VINCENT JELENIEWSKI	JOHN O'BRIEN	THOMAS J. WAGSTAFF
WILLIAM R. CURRIE	RALPH A. JENTARRA	JOSEPH FRANCIS O'BRIEN	ARTHUR G. WALBERG, JR.
CHARLES P. DEVINE	GEORGE F. JOHNSON	JOSEPH PARELL	ALBERT WALLWORK, JR.
PATRICK A. DI CIANCIA	WARREN F. JOHNSTON	STUART W. PEARSON	THOMAS F. WALSH
BERNARD W. DICK	THOMAS JONES	JOSEPH PEDEN, JR.	HENRY HEWSON WARD
RICHARD A. DILLON	WILLIAM B. JORDAN	JOSEPH PELUSO	WILFRED J. WARHURST
EUGENE I. DOCKRAY	EDWARD V. KACZYNSKI	RICHARD D. PERRY	REV. JOHN P. WASHINGTON
CORNELIUS A. P. DOLAN	SANFORD L. KAHN	CARL J. PETERSON	FRANCIS J. WAYTE
LEONARD A. DOMINKO	ANDREW C. KALIBATAS	FRANK R. PETTIGREW	GEORGE R. WAYTE
HERBERT A. DONEGAN	THOMAS KANE, JR.	RAYMOND PHILLIPS	WILLIAM H. WEILER
JOSEPH J. DONNELLY	JOSEPH J. KARCAUSKAS, JR.	OLIVER S. PIMM	JOHN E. WENIGER
ROBERT E. DONNELLY, JR.	STANLEY J. KAUKLIS	ALFRED PISCIOTTA	ROBERT S. WHITLA
WILLIAM J. DOOLEY	JOHN E. KESSLER	VINCENT PISCIOTTA	GEORGE A. WILLOUGHBY
PAUL DORSEY	BART W. KIERNAN	WILLIAM PLUNKETT	WILBUR I. WOOD
EDWARD J. DUNN	HOWARD D. KIERSTEAD	ANTHONY C. PORYCKI	EDWARD G. WRIGHT
EUGENE E. EBERT	JOSEPH F. KLOSS	VICTOR RADIN	ROBERT WYCKOFF
IVOR EMERSON	FREDERICK A. KOCH	CHARLES RAPPORT	HAIG P. WYLIE
PETER M. FEIGHAN	BRONISLAW KOPACKI	BERTEL R. RASMUSSEN	JOHN YUKNIEWICZ

A WWII Plaque Memorializing Fallen Kearny Fighting Men. The name of Eugene Rudomanski was inadvertently omitted from this honor roll, erected in Memorial Park at the intersection of Beech Street and Kearny Avenue in 1946. (Courtesy of George Rogers.)

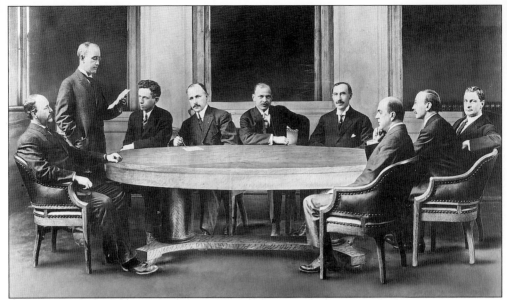

THE KEARNY TOWN COUNCIL, 1908–1910. Council members, from left to right, are Hugh Wilkie, Mayor Louis Brock, George McIntyre, Robert Torrance, Al Anderson, John Crane, John Nagle, Dan Bryan, and Will Chapman. (Courtesy of the Kearny Museum.)

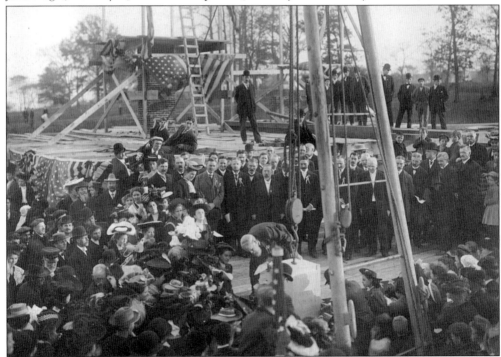

LAYING THE CORNERSTONE OF THE KEARNY FREE PUBLIC LIBRARY, OCTOBER 1906. Councilman John Davidson and Mayor Eugene Goldberg brought the idea for a library before the Kearny Town Council. The library, which stands at the intersection of Kearny and Garfield Avenues, was erected with $27,600 in philanthropic funds donated by steel magnate Andrew Carnegie. (Courtesy of the Kearny Museum.)

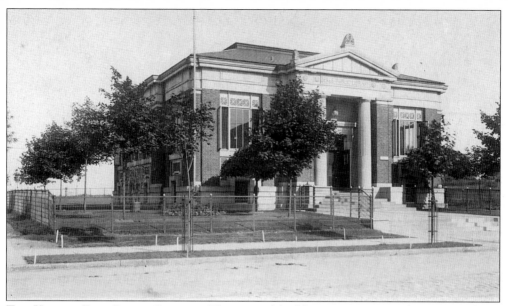

THE KEARNY FREE PUBLIC LIBRARY. The original building was constructed in 1906 and was dedicated and opened in July 1907. The Greek architectural style with Doric columns is typical of Andrew Carnegie libraries. In 1928, a $135,000 addition consisting of two stories and a basement was erected, more than doubling the library's floor space. The Kearny Museum now occupies the second floor.

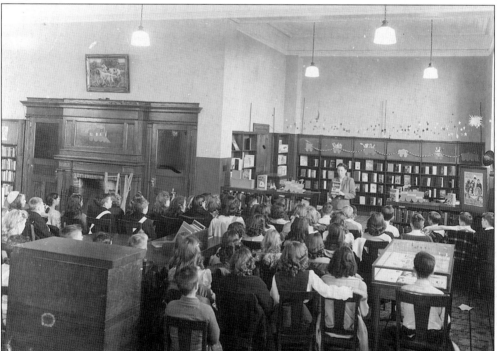

THE READING ROOM. Through the years many school-sponsored programs have brought children into the library. The librarian reads to a roomful of youngsters located in the back part of the library, which is dedicated to children. (Courtesy of the Kearny Free Public Library.)

THE BRANCH LIBRARY. By 1922, a branch library was operating out of the Roosevelt School, serving residents of Kearny's northern end. In 1927, this formerly private home on the northwest corner of Kearny and Stuyvesant Avenues was purchased for $25,000, and the branch library moved here. (Courtesy of the Kearny Free Public Library.)

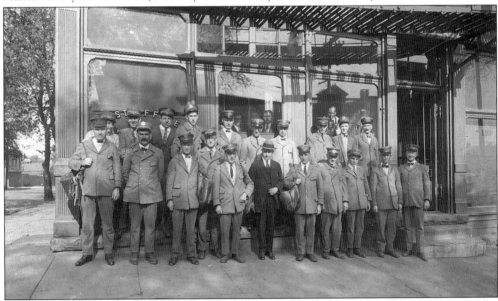

KEARNY'S POST OFFICE, C. 1922. On the corner of Midland Avenue and Devon Street in the heart of the downtown business district, postal workers pose in front of the Freeman Building that houses their office. James Freeman built this landmark c. 1891–1892, when he was the local postmaster and the acknowledged political boss of the town's Republicans. (Courtesy of the Kearny Museum.)

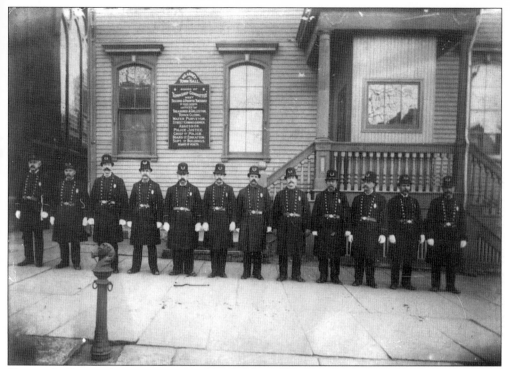

KEARNY'S POLICE DEPARTMENT, 1890. Looking like Keystone Cops, the mustached local police force poses in front of the Kearny Town Hall on Kearny and Woodland Avenues next to the Knox Presbyterian Church, the stained-glass windows of which are visible to the left. (Courtesy of the Kearny Museum.)

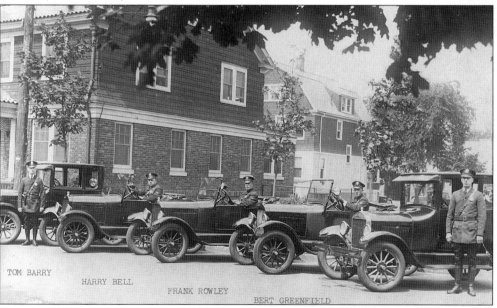

TOM BARRY
HARRY BELL
FRANK ROWLEY
BERT GREENFIELD

THE POLICE LINEUP. Several members of the Kearny Police Department face the camera from their official vehicles in 1925. Shown here, from left to right, are Tom Barry, Harry Bell, Frank Rowley, Bert Greenfield, and James Lackey. (Courtesy of the Kearny Museum.)

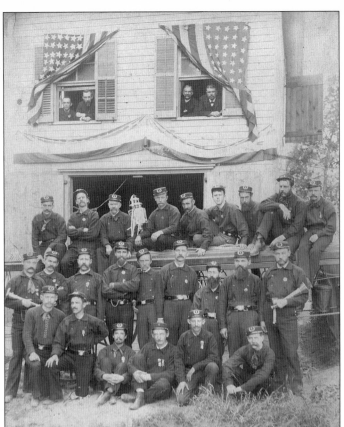

KEARNY'S FIRE DEPARTMENT, 1890. By unanimous vote of the township committee, the Kearny Fire Department was organized in January 1888 into three companies and the already existing Volunteer Truck Company of Arlington. The department's members were volunteers until a 1912 vote declared that its members would be paid. (Courtesy of the Kearny Museum.)

DASHING THROUGH THE SNOW WITH A SLED FOR THE HOSE, 1920. Kearny Fire Department No. 2 Capt. John Lone, Jim Stack, and Tom Lloyd make their way through the Kearny Castle Woods. The castle is visible on the far right. (Courtesy of the Kearny Museum.)

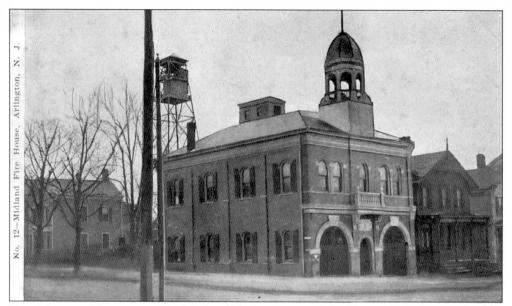

No. 12—Midland Fire House, Arlington, N. J.

THE MIDLAND FIREHOUSE. The Midland Firehouse, site of the Kearny Hose Company No. 3 and Truck Company No. 1, was dedicated in 1897. A new firehouse was built on this site in 1976.

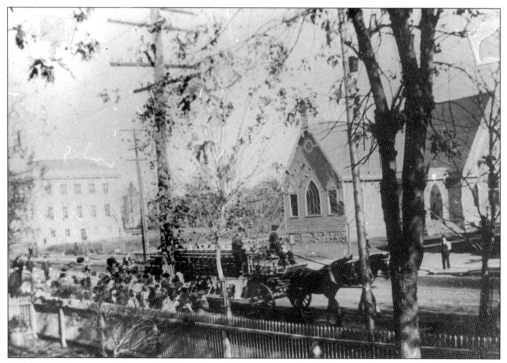

A HORSE-DRAWN TRUCK. Before the whirring sounds of the engines, trucks like this one pictured in 1911 moving along Kearny Avenue by Berlin Street (changed to Liberty Street as a result of WWI) were used for fighting fires. (Courtesy of the Kearny Museum.)

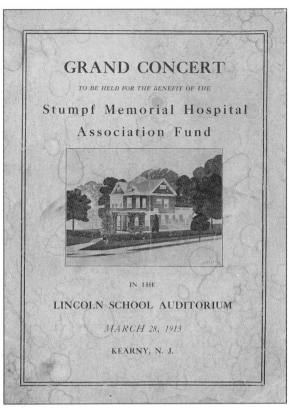

GRAND CONCERT

TO BE HELD FOR THE BENEFIT OF THE

Stumpf Memorial Hospital
Association Fund

IN THE

LINCOLN SCHOOL AUDITORIUM

MARCH 28, 1913

KEARNY, N. J.

STUMPF MEMORIAL, KEARNY'S FIRST HOSPITAL. The hospital was named for Mrs. and Mrs. Jacob Stumpf. In 1912, the Stumpfs gave their home, shown in the center of this 1913 benefit concert program, and several lots on the corner of Bergen Avenue and Elm Street to Kearny for a hospital. (Courtesy of the Kearny Museum.)

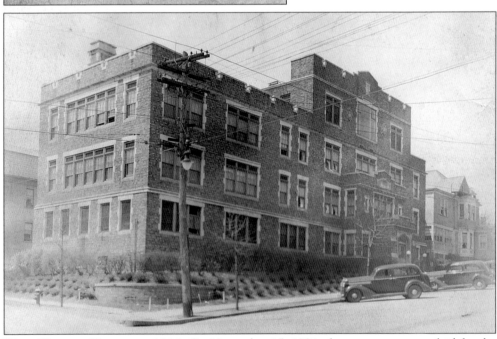

WEST HUDSON HOSPITAL, 1936. On November 15, 1924, the cornerstone was laid for the new 52-bed West Hudson Hospital building on the site of the former Stumpf Memorial facility. (Courtesy of Craig Stewart.)

IN KEARNY TRADITION.
The Brian Bord Irish
Pipe Band parades
down Kearny Avenue
in this 1948 Memorial
Day event. (Courtesy
of Alberta Gauch.)

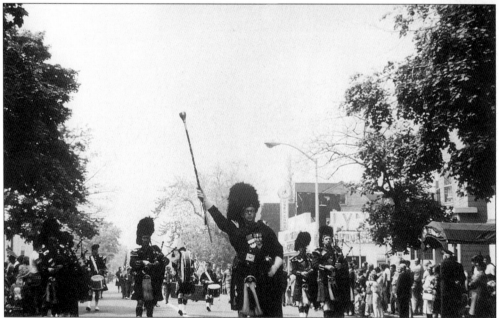

NO KEARNY PARADE IS COMPLETE WITHOUT A BAGPIPE BAND. In the 1968 Memorial Day parade, the St. Columcille United Gaelic Pipe Band marches along Kearny Avenue, near Pavonia, led by J. McGonigal, pipe major. Formed in 1949 by Sean McGonigal, the band is one of the oldest in New Jersey. An immigrant from Glasgow, Scotland, founder McGonigal had a sign-painting business. He suffered a fatal heart attack while leading his beloved band in the town's 1965 Memorial Day parade. (Courtesy of Craig Stewart.)

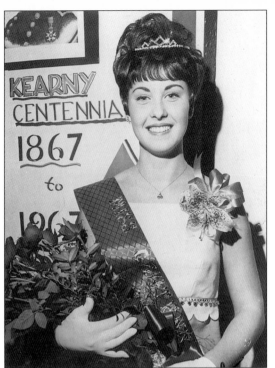

HERE SHE COMES, MISS CENTENNIAL. Ann Cali, an 18-year-old honors graduate of Kearny High School and a teller at Equity Savings, was crowned Miss Centennial as Kearny celebrated its past 100 years in 1967. (Courtesy of the Kearny Museum.)

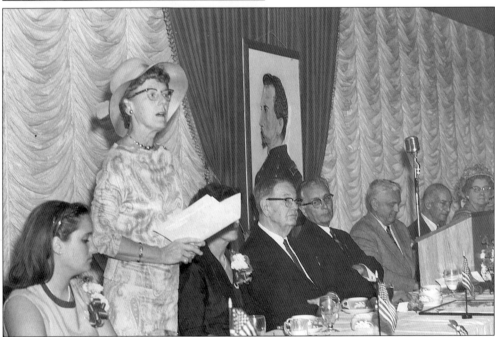

JESSIE HIPP WELCOMING GENERAL KEARNY'S KIN. At the centennial celebration, town historian and centennial committee member Jessie Hipp says a few words to welcome relatives of Philip Kearny, Mrs. Bowers and her daughter of Fair Haven. Seated, from left to right, are Diana Kearny Bowers, Mrs. Bowers, Mr. Latham, Mayor Healey, Dr. Tink, Mr. Bates, and Mrs. Shanks. (Courtesy of the Kearny Museum.)

Three

LOCAL BUSINESS

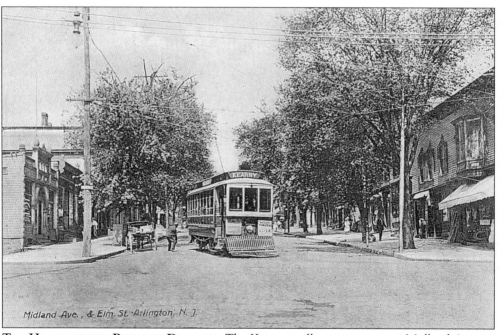

Midland Ave., & Elm St. Arlington, N. J.

THE HEART OF THE BUSINESS DISTRICT. The Kearny trolley moves east on Midland Avenue to turn northward onto Elm Street. This was the center of Kearny's downtown business area where horse-drawn carts and motorized transport coexisted. (Courtesy of Norman Prestup.)

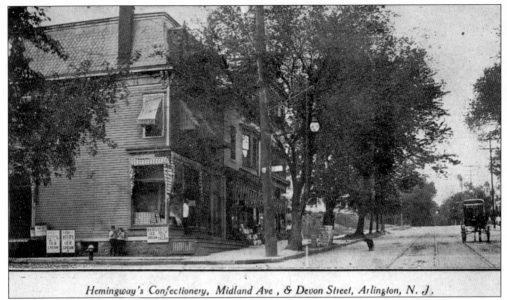

Hemingway's Confectionery, Midland Ave , & Devon Street, Arlington, N. J.

HEMINGWAY'S CONFECTIONERY. Two boys enjoy Reid's ice cream from this confectionery located on the corner of Midland Avenue and Devon Street. A garage currently occupies the site.

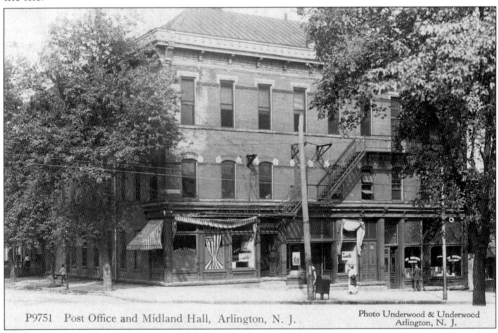

P9751 Post Office and Midland Hall, Arlington, N. J. Photo Underwood & Underwood
 Arlington, N. J.

THE FREEMAN BUILDING. On the northeast corner of Midland Avenue and Devon Street, in the heart of the local business district, stands the Freeman Building. At the beginning of the 20th century, the building contained the post office. Later, it also housed an auditorium, making it a cultural and entertainment center. In 1895, businesses operating from the building included Wilbur Yerkes, fresco painter and paper hanger; Molloy & Woods, printers, stationers, and bookbinders; J.B. Thomson, chemist and pharmacist; G.E. Teets, architect; and Dr. L.E. Estler, dentist. Still standing, the brick structure continues to bear the name the Freeman.

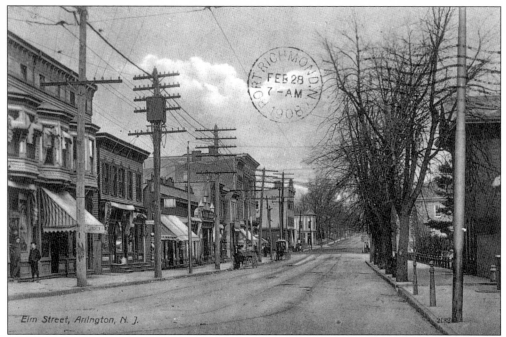

ELM STREET. Businesses line Elm Street on both its east and west sides. In the top view, taken *c.* 1908, note the hitching posts to the right in front of the newsstand. The bottom view, taken later, shows more buildings and no hitching posts.

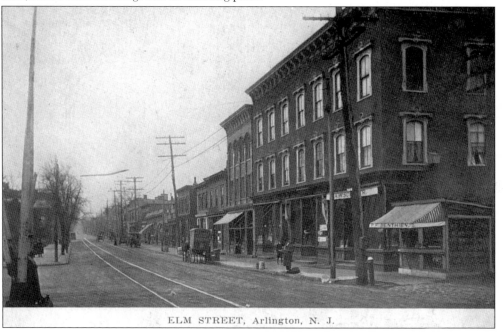

ELM STREET, Arlington, N. J.

P9756 Midland Avenue looking east, Arlington, N. J. Photo Underwood & Underwood, Arlington, N. J.

MIDLAND AND BEECH. Looking eastward, this corner boasts a shop selling Victrolas. The dirt hillock on Chestnut Street was later developed. (Courtesy of the Kearny Museum.)

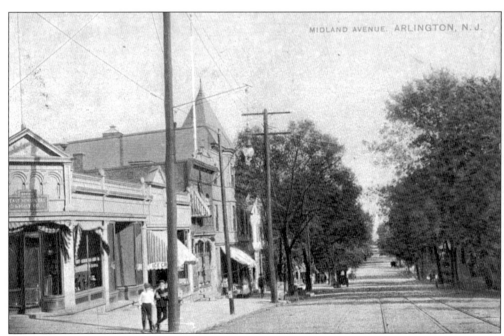

MIDLAND AVENUE. ARLINGTON, N. J.

THE CORNER OF MIDLAND AND CHESTNUT. This 1912 view looking eastward features the East Newark Gas Light Company.

40

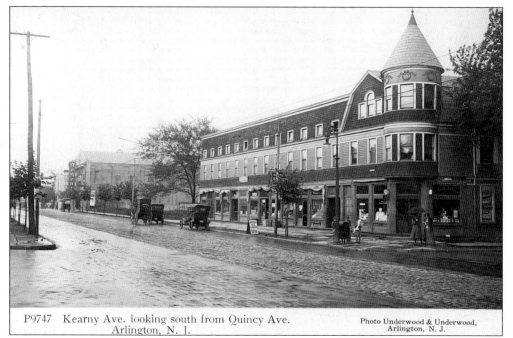

P9747 Kearny Ave. looking south from Quincy Ave.
Arlington, N. J.

Photo Underwood & Underwood,
Arlington, N. J.

THE CORNER OF KEARNY AND QUINCY. The Regent Theater, destroyed in a fire decades later, stood on the west side of Kearny Avenue south of Quincy Avenue. The turreted building on the corner still stands, although it has fallen into a state of disrepair.

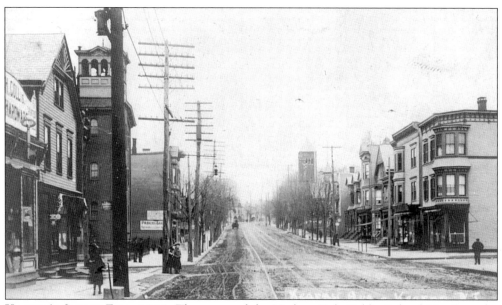

KEARNY'S SOUTH END, 1906. The tower of the Nathan Hale Public School No. 2 on the left and the steeple of the Knox Presbyterian Church on the right indicate that this view is looking north from Harrison. A hardware store and a bar flank the school. (Courtesy of the Kearny Museum.)

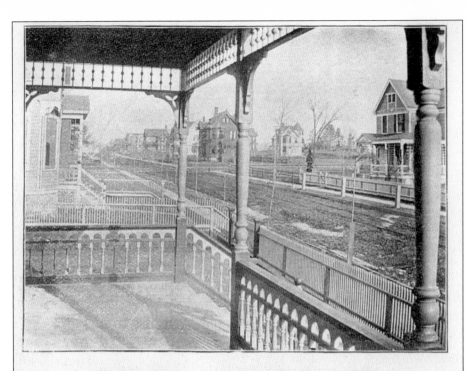

❧ REAL ESTATE ❧

CHOICE BUILDING SITES and LOTS for Sale
ON THE
EILSHEMIUS TRACT,
At ARLINGTON, N. J., near R. R. Station and also on the Heights.

PROPERTY CAREFULLY RESTRICTED. GOOD STREETS.

FLAGGED AND SEWERED.
AQUEDUCT WATER.
GAS AND ELECTRIC LIGHT.

Liberal Terms . . .
. . . Title Perfect.

H. G. & F. E. EILSHEMIUS,
265 BROADWAY, NEW YORK, or at their Arlington Office,
▲ ▲ ▲ ▲ KEARNY AVE., NEAR COLUMBIA AVE.

Also Insurance AGENTS AT ARLINGTON, N. J.
Germania Fire and Phoenix Insurance Companies,

EILSHEMIUS TRACT REAL ESTATE. This advertisement appeared in the 1895 *Picturesque Arlington*, a booklet designed to attract businessmen to settle in the northern section of Kearny. The huge tract was described as "one of the choicest pieces of property in location and natural beauty, beginning from the Passaic River, with a frontage of nearly 700 feet, extending north from West Arlington Station on the New York and Greenwood Lake Railroad, and running across Arlington beyond Schuyler Avenue, a distance of about a mile." The tract included the site of the former Laurel Hill estate, which by 1895 had been surveyed and laid out into lots, streets, and avenues.

42

EDWARD A. STRONG ❧

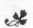

REAL ESTATE AND ❧
❧ ❧ INSURANCE,

STRONG BUILDING.

EDWARD A. STRONG, REAL ESTATE AND INSURANCE. Located at 168 Midland Avenue, this real estate agency offered lots on Belgrove Drive, Oakwood Avenue, and Pavonia and Quincy Avenues, noting that all were located south of and within a 5- to 10-minute walk of the railroad depot. Prices were $200 and up. North of the railroad, the agency offered lots for $275 and up in the location known as the Heights, where more than 250 beautiful homes were built on former farmland. New York City-born, Edward A. Strong came to Arlington in 1882 and entered the real estate and insurance business in 1891.

43

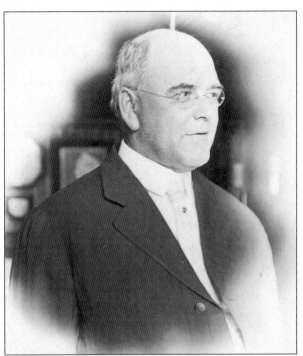

H.C. SMITH, REAL ESTATE AGENT. Kearny and Arlington offered plenty of land-development opportunities. (Courtesy of the Kearny Free Public Library.)

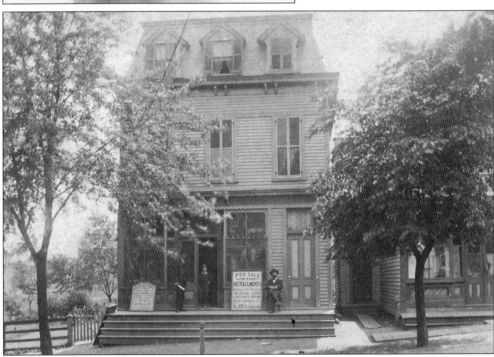

LOUIS LINDBLOM'S BUSINESS. In the 1890s, the Arlington Bank, the home and business of Louis W. Lindblom, was located at 162 Midland Avenue. Lindblom was born in Sweden and came to America in 1870. When he arrived in Arlington in 1879, he entered the real estate business and eventually became a banker. He was a charter member of the Kearny Building and Loan Association. (Courtesy of the Kearny Museum.)

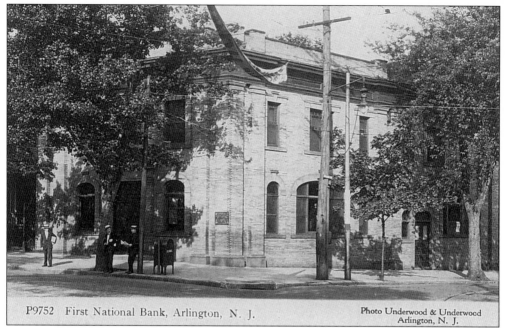

P9752 First National Bank, Arlington, N. J.

Photo Underwood & Underwood
Arlington, N. J.

THE FIRST NATIONAL BANK. Until 1910, the First National Bank was located in a small store on Midland Avenue near Elm Street. In that year, the bank moved to the northeast corner of the intersection of Midland and Kearny Avenues. It was originally called the First National Bank of Arlington. (Courtesy of Norman Prestup.)

THE KEARNY BUILDING & LOAN ASSOCIATION. First formed in 1884 with previous offices at 162 Midland Avenue just below Devon Street, the Kearny Building & Loan Association moved to this Colonial-style structure of red brick with white columns in 1928. The current Kearny Federal Savings & Loan Association replaced the building. (Courtesy of Norman Prestup.)

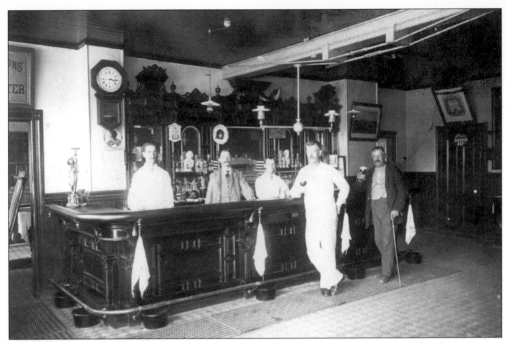

THE FOREST HOTEL, 1895. Located on the northeast corner of Midland Avenue and Forest Street, the Forest Hotel advertised itself as a summer resort or permanent home and offered quick, convenient access to the Erie Railroad at the Arlington Depot. Theodore F. Wollenhaupt was the proprietor when this photograph was taken in 1895. At the time, the hotel stood in a dense forest, hence its name. Pictured around the hotel bar, from left to right, are August Wollenhaupt, Theodore F. Wollenhaupt, Albert Simmons, M. DuBois, and Billy Seydmore. (Courtesy of the Kearny Museum.)

THE LODI HOTEL,

JOHN MOLYNEUX, Prop.

For a Century a Famous Tavern, now the most comfortable, best= appointed, and up=to=date hotel and saloon in West Hudson.

Finest Stock of Liquid and Solid Refreshments.

Business Men's Noon-day Lunch a Special Feature.

Harrison and Schuyler Avenues,

KEARNY, N. J.

THE FAMOUS LODI HOTEL. One of the oldest structures in town, the Lodi Hotel was a mainstay of food, drink, and lodging. This advertisement appeared in the *Kearny Record* in 1904. Contrary to the popular misconception that the entire hotel was destroyed by fire in 1902, the Lodi operated as a tavern until Prohibition in 1918. (Courtesy of the Kearny Museum.)

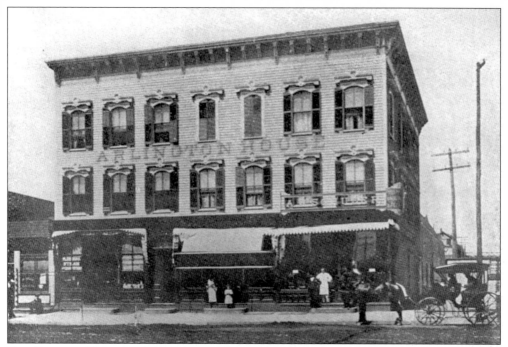

THE BED AND BOWL AT THE ARLINGTON HOUSE. The Arlington House hotel, run by A.W. Schuler in 1895, accommodated 25 guests, 200 at meals, and offered livery stables, mineral water bottling, and regulation-sized bowling alleys. It was located on Elm Street near the railroad.

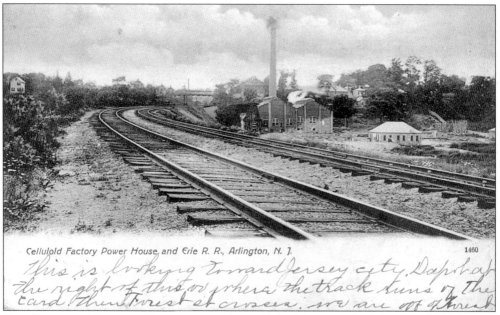

Celluloid Factory Power House, and Erie R. R., Arlington, N. J. 1460

THE CELLULOID FACTORY POWERHOUSE. The celluloid factory, which became the Arlington Company and a subsidiary of the DuPont Company, reached from Elm Street to Snake Hill. In the early 1890s, it consisted of a one-story building at the corner of Forest Street and the Erie Railroad. (Courtesy of Craig Stewart.)

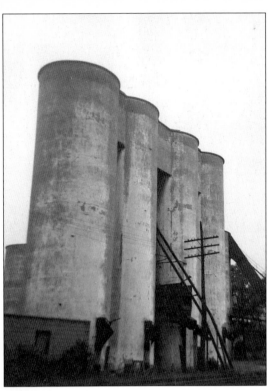

J. SMITH COAL & SALT. One of the largest distributors of bituminous coal in the metropolitan area, this company was headquartered on Johnson Avenue. Its storage silos are shown here at the Erie Railroad. (Courtesy of Frank Nicolle.)

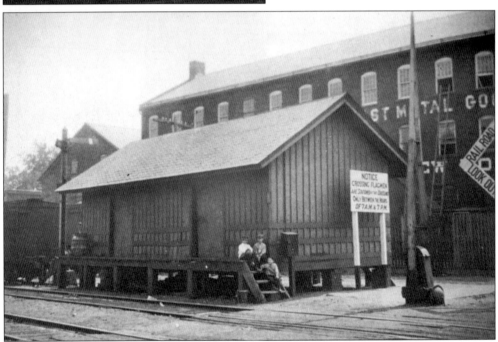

F.H. LOVELL & CO. Boys sit by the building behind the Arlington freight station that houses F.H. Lovell and Co., founded in 1902. The building eventually became the Lovell-Dressel Company, manufacturers of marine and railway lamps and fixtures. (Courtesy of Craig Stewart.)

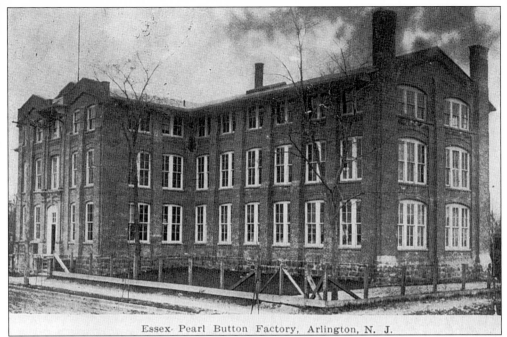

Essex Pearl Button Factory, Arlington, N. J.

ESSEX PEARL BUTTON COMPANY, C. 1904. This manufacturer was located at 720 Devon Street, between Stewart and Laurel Streets. (Courtesy of Norman Prestup.)

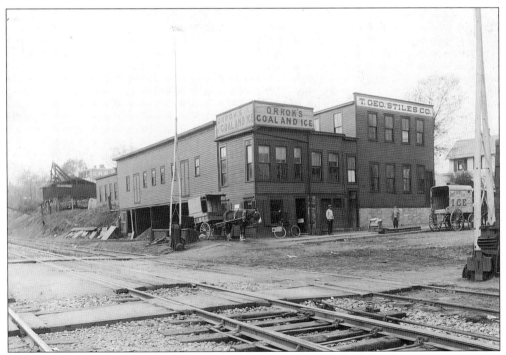

TRANSPORTATION IS CRITICAL TO LOCAL BUSINESS. It was certainly not uncommon to find businesses along the railroad tracks. Shown here are Orrok's Coal and Ice and the T. George Stiles Company. (Courtesy of the Kearny Free Public Library.)

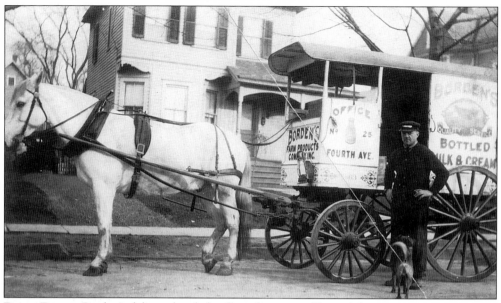

DAILY DAIRY. Borden's delivers bottled milk and cream to Kearny's homes.

THE CORNER OF KEARNY AND WOODLAND. Embalming services are offered from the building on the southwest corner of this intersection. The view looks south toward the Erie Railroad cut and East Newark. (Courtesy of the Kearny Museum.)

HEATH AND NORRIS, 1895. This dry goods concern, which also sold notions, carpets, and oil cloths, was open for business on Midland Avenue. When this photograph was taken, the business had just moved out of the Freeman Building.

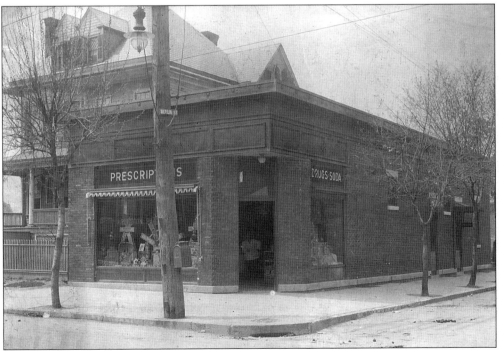

THE C. ORVILLE RIECK & COMPANY, 1913. C. Orville Rieck and Howell Rieck operated their business at 379 Kearny Avenue at Berlin (now Liberty) Street. (Courtesy of the Kearny Museum.)

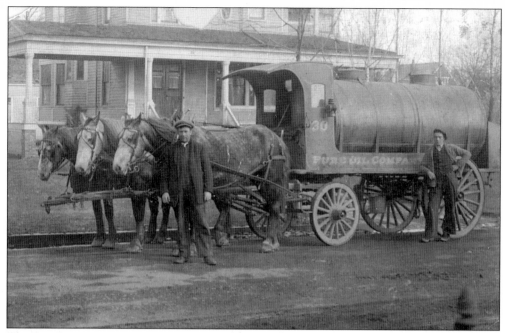

THE PURE OIL COMPANY. Home delivery by Kearny's Pure Oil Company kept local residents warm. (Courtesy of the Kearny Museum.)

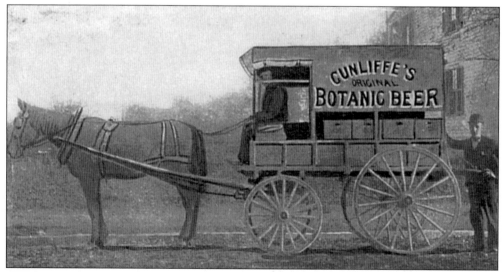

CUNLIFFE'S "BOTANIC" BEER, C. 1895. George Cunliffe came to America from England in 1882 and worked at the Clark Thread Mills for six years. In 1889, he came up with the concept of a non-alcoholic beverage, "botanic" beer, and introduced it to America.

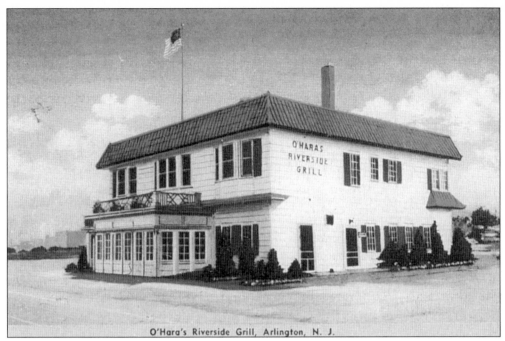

O'Hara's Riverside Grill, Arlington, N. J.

O'HARA'S RIVERSIDE GRILL, C. 1946. On the west side of Passaic Avenue stood this popular eatery. It was replaced by Lyle's and is now a parking lot. (Courtesy of Norman Prestup.)

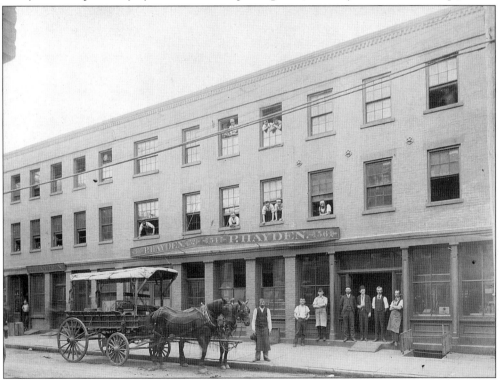

EVERYBODY WANTS TO BE IN THE PICTURE. Whether on the ground floor or looking out the window, employees of P. Hayden pose for this group shot. (Courtesy of the Kearny Museum.)

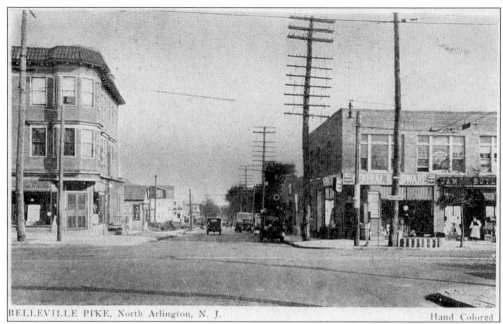

BELLEVILLE PIKE, North Arlington, N. J. Hand Colored

BELLEVILLE PIKE. This shopping district is centered at the intersection of Kearny's Kearny Avenue, the Belleville Turnpike, and North Arlington's Ridge Road. Many of the buildings still exist today, although the businesses do not. The Belleville Turnpike was laid of cedar logs across the meadows in 1755 and macadamized in 1914. (Courtesy of Norman Prestup.)

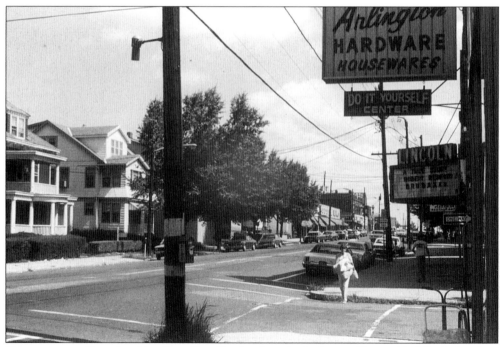

TOWARDS THE PIKE. Looking from Van Cortlandt, a single feature film entitled *Brubaker* plays at the Lincoln movie theater in September 1980. The theatre is now a multiplex. (Courtesy of Craig Stewart.)

54

Four

AN INDUSTRIAL MECCA

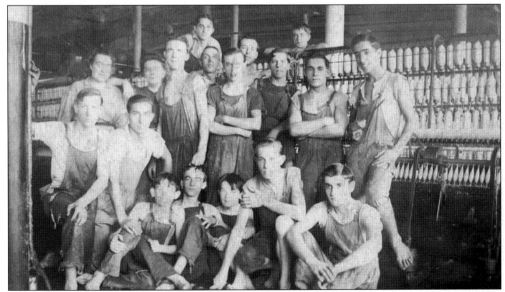

A FEW GOOD MEN. This postcard shows Clark Thread Company employees posing in front of thread spindles. The Scotland-based company, which brought over thousands of Scottish immigrants, opened in Kearny in 1875 with two large mills and added two more in 1890. Second from the left is George Rogers, and standing in the center row on the right is his brother Bill Rogers. (Courtesy of George Rogers.)

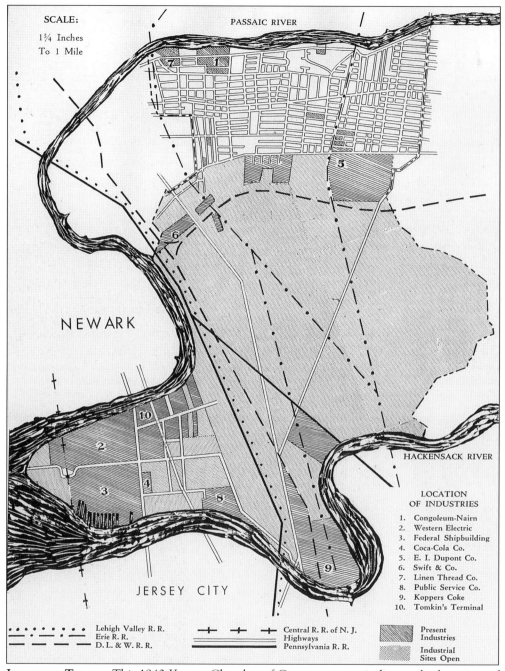

SCALE:
1¾ Inches
To 1 Mile

PASSAIC RIVER

NEWARK

HACKENSACK RIVER

JERSEY CITY

LOCATION
OF INDUSTRIES

1. Congoleum-Nairn
2. Western Electric
3. Federal Shipbuilding
4. Coca-Cola Co.
5. E. I. Dupont Co.
6. Swift & Co.
7. Linen Thread Co.
8. Public Service Co.
9. Koppers Coke
10. Tomkin's Terminal

• • • • • • • Lehigh Valley R. R.
— — — — — Erie R. R.
— — — — — D. L. & W. R. R.

+ — + — + Central R. R. of N. J.
——————— Highways
═══════ Pennsylvania R. R.

▨ Present
Industries

▨ Industrial
Sites Open

INDUSTRY TITANS. This 1940 Kearny Chamber of Commerce map indicates the locations of the major industries already operating in Kearny, many of which had been in business for several decades. Kearney was ideally located: at the intersection of the Passaic and Hackensack Rivers, between Jersey City and Newark, with easy access to highways, waterways, and railroads.

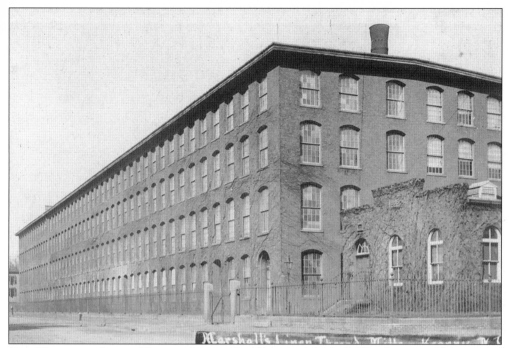

THE MARSHALL LINEN THREAD MILLS. In 1883, the Marshall Flax Spinning Company of England erected a large plant in Kearny known as the Linen Thread Company. The company's need for experienced flax spinners brought an influx of workers from the British Isles.

THE SMOKESTACK AT MARSHALL'S MILLS. The recognizable smokestack at Marshall's Mill stands out on the skyline. The last products made here included aluminum bats. (Courtesy of Frank Nicolle.)

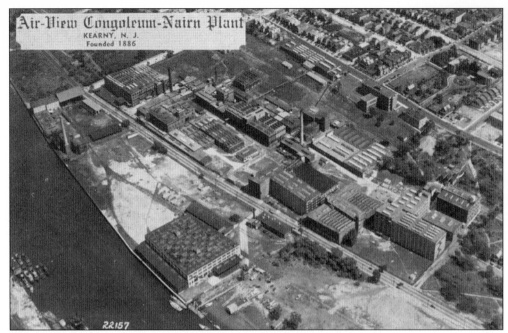

AN AERIAL VIEW OF CONGOLEUM-NAIRN. In 1887, Scotsman Sir Michael Nairn established the Nairn Linoleum Company, which flourished right from the start. The following year, Nairn brought over Scottish families employed in floor coverings to work here. The company merged with the Congoleum Company of Philadelphia in 1924, placing it at the forefront of the world's linoleum industry as Congoleum-Nairn. It was located on the site of the former Kearny Castle.

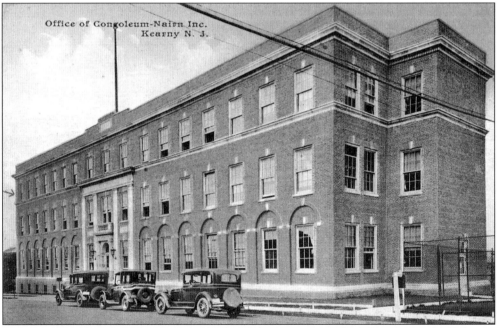

AN OFFICE AT CONGOLEUM-NAIRN. The hand-drawn arrow to the left points to the Belgrove Drive office of the postcard writer's husband at Congoleum-Nairn. The site now belongs to the Clara Maass Continuing Care Center at Kearny.

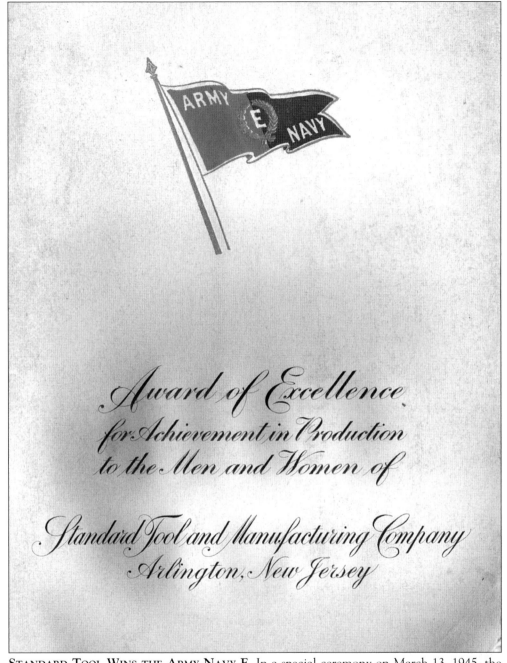

Award of Excellence
for Achievement in Production
to the Men and Women of

Standard Tool and Manufacturing Company
Arlington, New Jersey

STANDARD TOOL WINS THE ARMY-NAVY E. In a special ceremony on March 13, 1945, the Standard Tool and Manufacturing Company of Arlington received the Army-Navy E, the Award of Excellence for Achievement in Production. Like the award given to Federal Ship Building and Western Electric, it consisted of a flag to be flown above the plant and a lapel pin for each employee. Upon accepting the award, M.J. Keating, Standard Tool's vice-president, humbly stated, "We have done nothing beyond the performance of our ordinary duties to deserve this honor." Standard Tool first began operations in town in 1908 as a small machine shop that made metal parts. (Courtesy of Herman Gauch.)

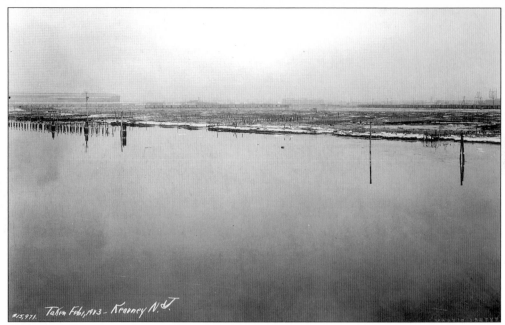

AN EMPTY PARCEL OF LAND. There was little in this February 1923 view that would suggest to the most optimistic person that the marshy site would one day become the home of one of Kearny's strongest industrial employers, the Western Electric Company. (Courtesy of AT&T Archives.)

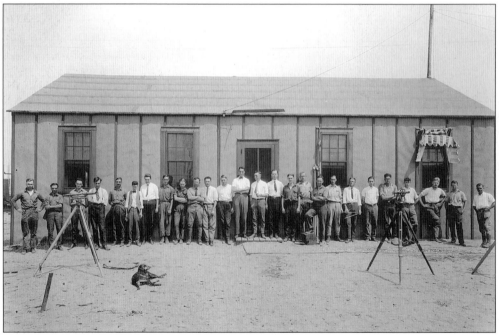

THE FIRST WESTERN ELECTRIC COMPANY EMPLOYEES. The first building and the first group of Western Electric employees are pictured on the grounds at Kearny in 1923. The men pictured here formed the technical field forces, operating under Mr. Kattelle, the company architect. (Courtesy of AT&T Archives.)

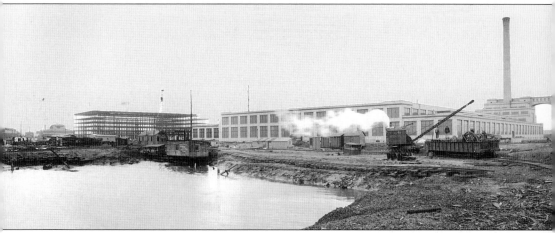

THE SITE OF THE KEARNY WORKS. This rear view shows the Western Electric Company's Kearny Works in 1925. (Courtesy of AT&T Archives.)

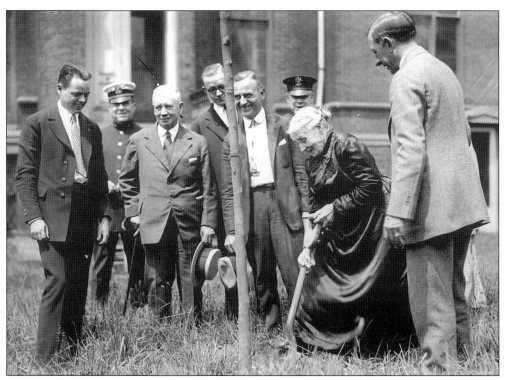

ELEANORE GILLIGAN TRANSPLANTING A SYCAMORE. Octogenarian and Kearny Castle proprietress Eleanore Gilligan digs the first spadeful of earth to transplant a sycamore tree from the Kearny Castle grounds into the soil at Western Electric's Kearny Works in 1925. Kearny Mayor Archibold looks on from the right. (Courtesy of AT&T Archives.)

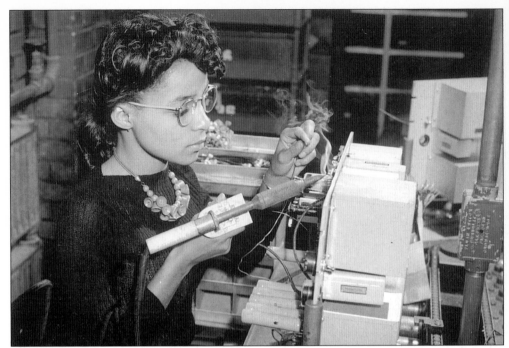

RUBY DEE AT THE WESTERN ELECTRIC COMPANY. Working for victory during WWII, wirewoman Ruby Dee solders the wiring in a demodulator panel. She occupied an important post along one of the Kearny Works's roller conveyors. She went on to become an accomplished actress. (Courtesy of AT&T Archives.)

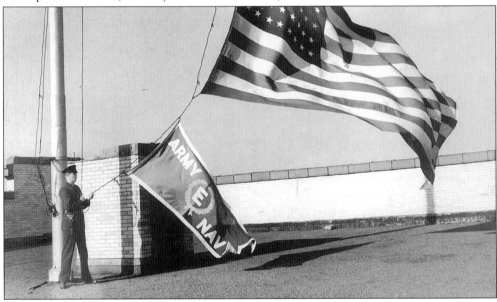

THE WESTERN ELECTRIC COMPANY'S ARMY-NAVY E. In 1906, the Navy instituted an award for excellence that became known as the Navy E. It evolved into the Army-Navy production award after the bombing of Pearl Harbor. The Western Electric Company's Kearny Works received the honor, and the Army-Navy E banner is shown here being hoisted above the plant's main building in 1942. (Courtesy of AT&T Archives.)

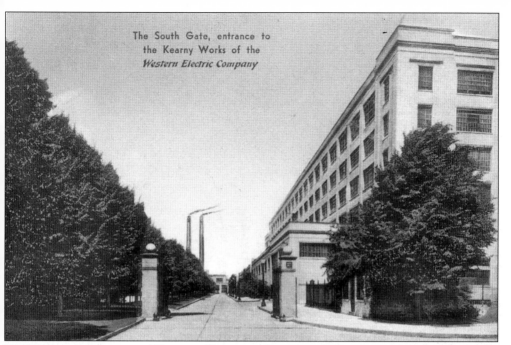

The South Gate, entrance to the Kearny Works of the *Western Electric Company*

THE SOUTH GATE OF THE WESTERN ELECTRIC COMPANY. The Kearny plant was one of the company's major manufacturing units serving the Bell System. It produced telephone cable, telephone switchboards, and other communications equipment. (Courtesy of Craig Stewart.)

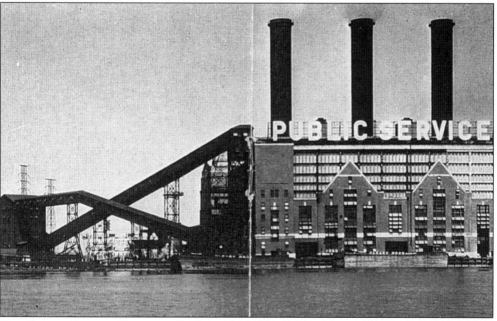

THE PUBLIC SERVICE ELECTRIC & GAS, 1940. The Public Service Electric Power Company was formed in April 1923 in order to erect the Kearny power plant that was to be leased back to the Electric & Gas Company. In 1927, Public Service bought the electric power company subsidiary for $25 million. Thomas Alva Edison was the guest of honor at its opening. Located on Fish House Road, this generating plant still operates today.

THE ARLINGTON WORKS
I. DU PONT DE NEMOURS & COMPANY. INC.
ARLINGTON. N. J.

THE E.I. DUPONT DE NEMOURS COMPANY, 1940. Founded in 1883, the Arlington Company eventually became a subsidiary of E.I. DuPont de Nemours Company in 1916. A pioneer in cellulose, the Arlington site became the center of DuPont operations in plastics. From a

Photo
Underwood & Underwe
New York — Londor

single small building, it grew to include more than 160 structures, covering more than 50 acres. (Courtesy of Norman Prestup.)

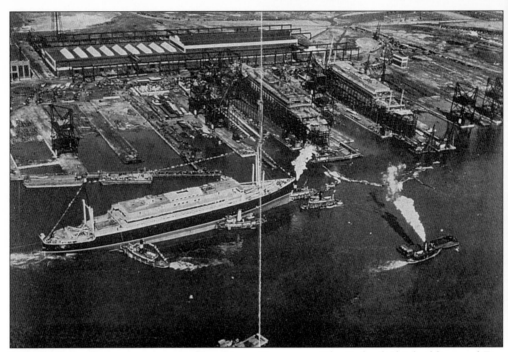

THE FEDERAL SHIPBUILDING AND DRY DOCK COMPANY. The Federal Shipbuilding and Dry Dock Company, a subsidiary of United States Steel Corporation, employed more than 50,000 people to meet WWII production demands at the Kearny Yards.

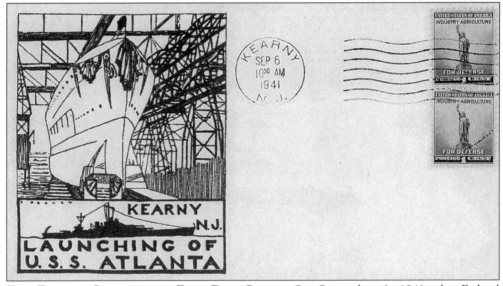

THE FEDERAL SHIPBUILDING FIRST-DAY COVER. On September 6, 1941, the Federal Shipbuilding launched the 6,000-ton cruiser, USS *Atlanta*, which is commemorated on this first-day cover. Sponsored by *Gone with the Wind* author Margaret Mitchell, a guest of the Atlanta-headquartered Coca-Cola Company at its Kearny plant for the ship's launch, the USS *Atlanta* was commissioned at Brooklyn Navy Yard on December 24, 1941, and dedicated to the "vengeance of Pearl Harbor." Unfortunately, the ship was lost in a battle off the Guadalcanal in mid-November 1942. (Courtesy of Norman Prestup.)

Five

AT THE CROSSROADS

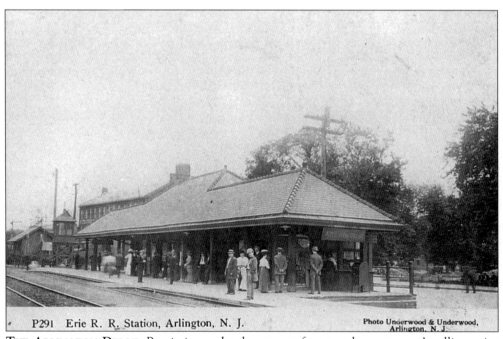

P291 Erie R. R. Station, Arlington, N. J. Photo Underwood & Underwood,
 Arlington, N. J.

THE ARLINGTON DEPOT. Proximity to the depot was often a real estate agent's selling point to lure commuting businessmen to the town. The depot was completed in October 1873 and was located on the Greenwood Lake Division of the Erie Railroad. The landmark played a significant role in the development of Arlington's business district. (Courtesy of Norman Prestup.)

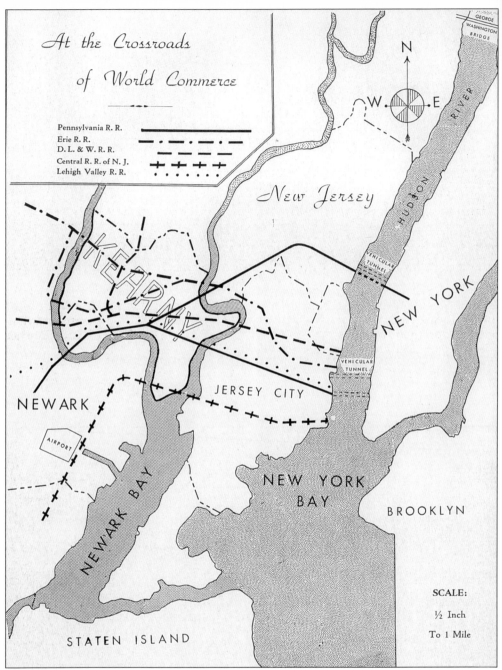

At the Crossroads
of World Commerce

Pennsylvania R. R.
Erie R. R.
D. L. & W. R. R.
Central R. R. of N. J.
Lehigh Valley R. R.

New Jersey

GEORGE WASHINGTON BRIDGE

HUDSON RIVER

NEW YORK

VEHICULAR TUNNEL

VEHICULAR TUNNEL

KEARNY

NEWARK

JERSEY CITY

AIRPORT

NEWARK BAY

NEW YORK BAY

BROOKLYN

STATEN ISLAND

SCALE:

½ Inch

To 1 Mile

THE CROSSROADS BRING INDUSTRY. This 1940 map indicates the railroads—Pennsylvania, Erie, DL&W, Central, and Lehigh Valley—that crisscrossed the town on their way to major cities. Newark Bay, the Newark Airport, and road and tunnel access also attracted important commerce to the area.

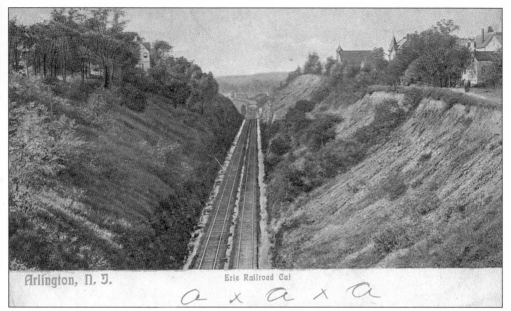

Arlington, N. J. Erie Railroad Cut

THE ERIE RAILROAD CUT. The Erie Railroad cut was completed in 1873, opening Arlington and Kearny to New Yorkers seeking refuge in "the country," but within commuting distance from their work in the city. This view was taken *c.* 1907.

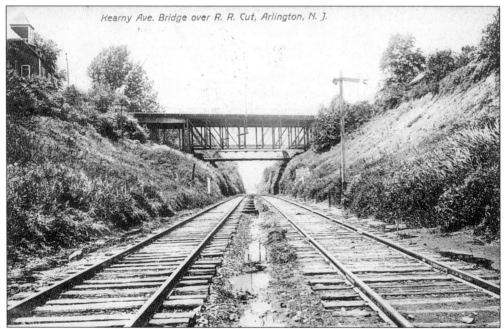

Kearny Ave. Bridge over R. R. Cut, Arlington, N. J.

KEARNY AVENUE BRIDGE OVER THE RAILROAD CUT. This view of the cut was photographed *c.* 1907.

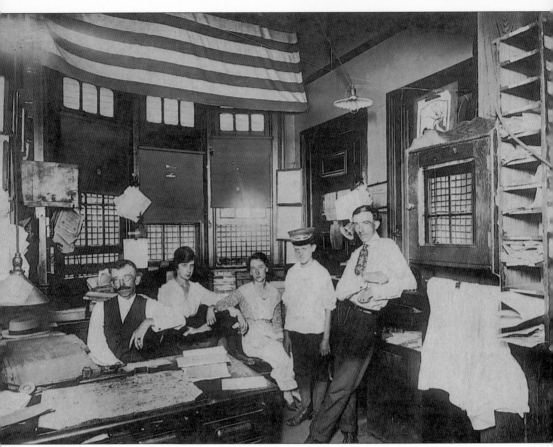

INSIDE THE ARLINGTON STATION, 1917. Staff members responsible for the smooth and efficient operation of the Arlington Station stop long enough from their busy schedule to pose for this picture. The young boy wearing the hat is 12-year-old John A. Parks, who delivered Western Union telegrams on his bicycle. The man on the left keeps a detailed ledger, obviously painstaking work, illuminated by the low-hanging lamp overhead. A candlestick telephone also adorns his desk. (Courtesy of Henry Parks.)

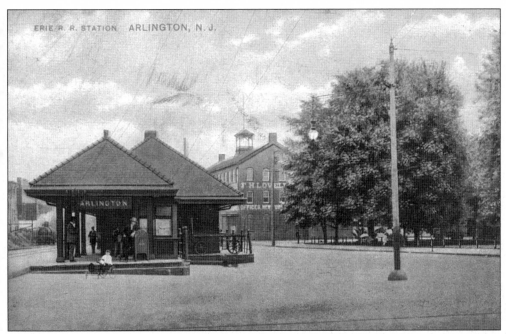

A TRAIN APPROACHES ARLINGTON STATION. An eastbound Erie Railroad locomotive comes through Arlington Station at Forest Street.

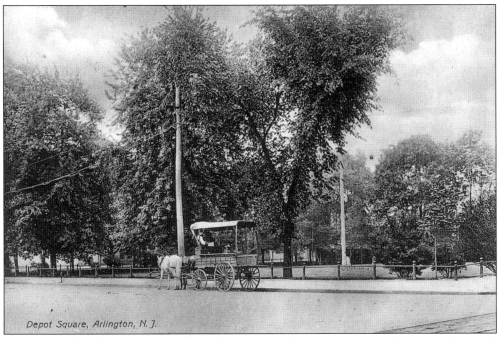

THE PARK AT DEPOT SQUARE. A horse-drawn cart makes its way around the park to the south of Arlington Station in this 1908 view.

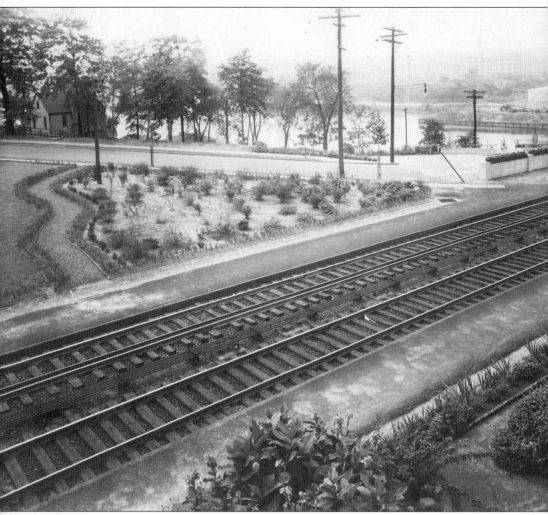

THE WEST ARLINGTON STATION, 1934. In 1874, the Montclair Railroad, later a part of the Erie Railroad, was built and made a cut through the center of town to avoid a high hill on which the Arlington section of Kearny was built. The railroad bridge built at that time crossed the Passaic at a height of about 50 feet. The downgrade of North Midland Avenue and the upgrade of Passaic Avenue met at West Arlington Station; it was at this very dangerous

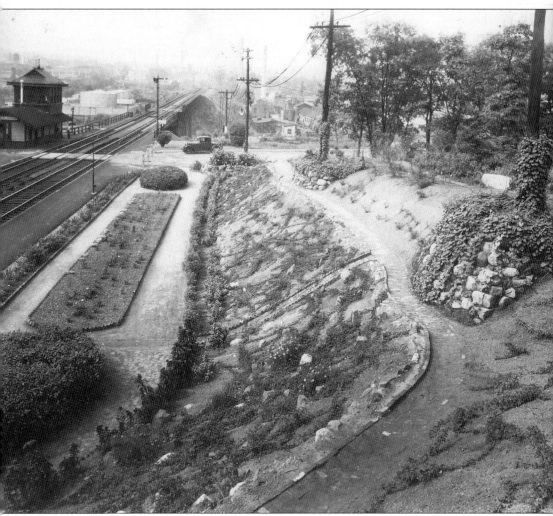

intersection that automobiles crossed the tracks to proceed north. River Road was moved out over the river at the point of the railroad, with bulkheads built to retain the fill and create the new underpass beneath the railroad tracks. The Arlington Garden Club put together a plan to beautify the station area, a long and tedious task that took place from 1933 to 1934. (Courtesy of the Kearny Museum.)

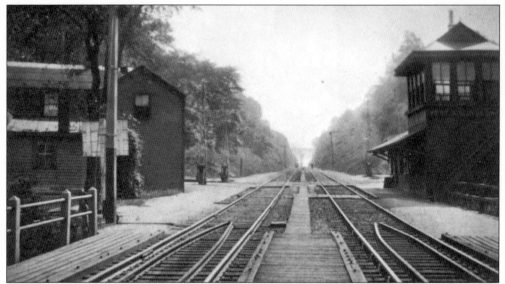

THE WEST ARLINGTON STATION. Erie's West Arlington station was built c. 1895, just after laying the double track through the cut. The original station was on the north side of the tracks and was the residence of John Dodd, who served as stationmaster, bridge tender, and ticket seller. During WWI, a detachment from the 113th infantry protected the bridge from sabotage and espionage. (Courtesy of Craig Stewart.)

THE WEST ARLINGTON STATION'S NORTH AND WEST TRACKS, 1934. Flowerbeds of cosmos, salvia, and guinea gold marigolds grace the grounds around the station. On the left is the Passaic River and Passaic Avenue (River Road) leading to the new underpass. On the right is Passaic Avenue from the railroad, joining Washington and Laurel Avenues beyond the road bend. (Courtesy of the Kearny Museum.)

Six
KEEPING THE FAITH

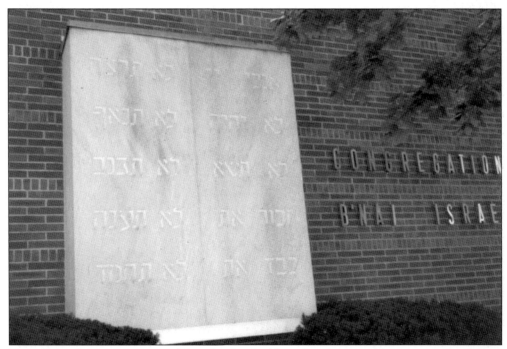

THE TEN COMMANDMENTS. Though the building has been sold to another religious organization, the tablets articulating the Ten Commandments in Hebrew still adorn the face of the former home of Kearny's Congregation B'nai Israel. (Courtesy of the Kearny Free Public Library.)

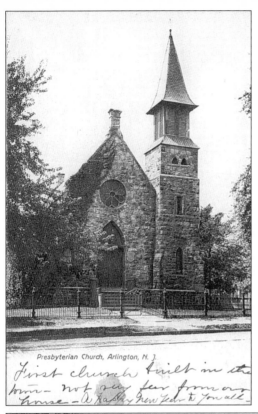

Presbyterian Church, Arlington, N. J.

First church built in the town — not very far from our house — A Happy New Year to you all

THE FIRST PRESBYTERIAN CHURCH. Home of the First Presbyterian congregation of Arlington, the 1879 structure, shown here at the beginning of the 20th century, was built with stone from the North Arlington quarry and stood on the southeast corner of Kearny and Midland Avenues. However, this location was an ideal one for local business, not worship. In 1913, plans were made to abandon the church and move to larger quarters on the southwest corner of Laurel and Kearny Avenues. (Courtesy of Norman Prestup.)

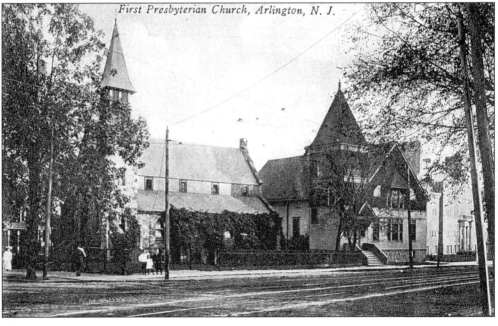

First Presbyterian Church, Arlington, N. J.

THE KNOX PRESBYTERIAN CHURCH. The Knox Presbyterian Church was dedicated in January 1882 on ground given to the church by Nancy Halstead, wife of Gen. Nathaniel Halstead. The Reverend J. Kirby Davis was installed as pastor.

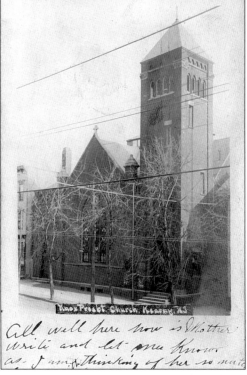

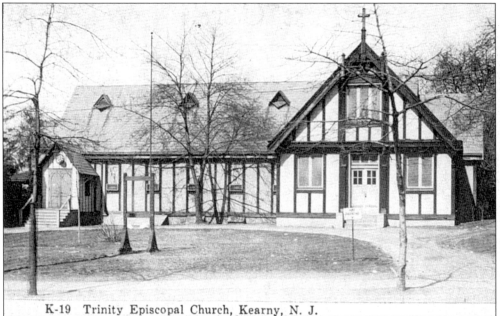

K-19 Trinity Episcopal Church, Kearny, N. J.

THE TRINITY EPISCOPAL CHURCH. The Trinity parish, established in 1886, acquired the land that had been the site of Public School No. 3 (the original Lincoln School) and the Kearny Fire House No. 3. The school served as the parish house until 1907 when it was purchased from the Town Council of Kearny to serve the needs of the Trinity mission exclusively. (Courtesy of Norman Prestup.)

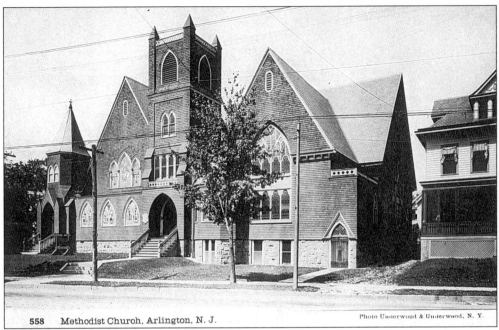

558 Methodist Church, Arlington, N. J. Photo Underwood & Underwood, N. Y.

THE METHODIST CHURCH. The First United Methodist Church held its first services in the Arlington Railroad Depot when the station was completed in 1873. Its first wooden church was built at Midland Avenue and Chestnut Street, now the site of the St. Stephen's School. The Kearny Avenue location was dedicated in January 1897. (Courtesy of Norman Prestup.)

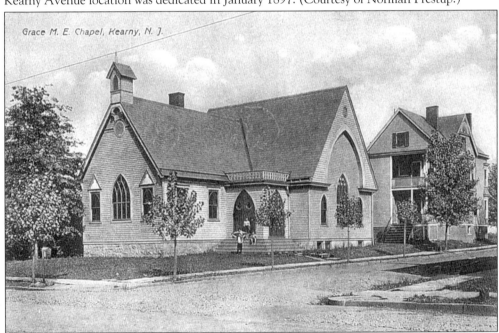

Grace M. E. Chapel, Kearny, N. J.

THE GRACE METHODIST CHURCH. Beginning in a small chapel at 368–370 Kearny Avenue in 1895, the Grace United Methodist Church moved within just a few years to its present location at 380 Kearny Avenue. This location, shown in 1902, was expanded in 1904 by two vacant lots to keep pace with the congregation's growth. (Courtesy of Norman Prestup.)

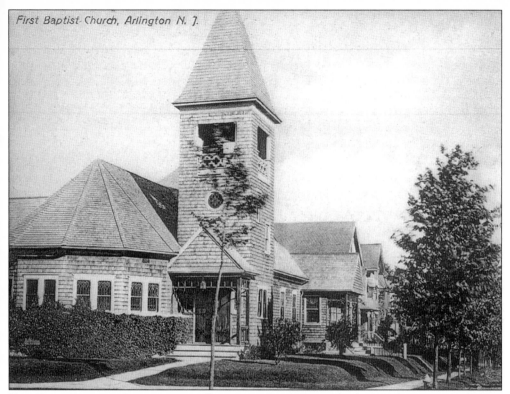

First Baptist Church, Arlington N. J.

THE FIRST BAPTIST CHURCH. Initially organized in 1891 at the home of Deacon W.H. Van Meter with 24 members, the First Baptist Church stood on the corner of Columbia and Kearny Avenues. The new church on the corner of Washington Avenue was dedicated in 1965. (Courtesy of George Rogers.)

THE SWEDISH CHURCH. Religious meetings were conducted in Swedish within the town as early as 1883. The chapel, given to the Union, cost $821 and stood on the corner of Oakwood Avenue and Forest Street. It was open to all Protestant denominations. Eventually, the Union split into three Swedish congregations in Arlington with three separate places of worship: Lutheran, Baptist, and Methodist. (Courtesy of Norman Prestup.)

Swedish Church, Arlington, N. J.

THE FIRST LUTHERAN CHURCH. The first Swedish Evangelical Lutheran congregation formed in 1890 and initially held meetings at the Odd Fellows Hall and then in a structure on Elm Street near Oakwood Avenue. Later, the congregation moved to a location on the north side of Oakwood Avenue just west of Kearny Avenue and eventually to the church shown here. The First Lutheran Church has been lauded for its architectural design and has served as the subject of dozens of articles in architectural trade journals. (Courtesy of Norman Prestup.)

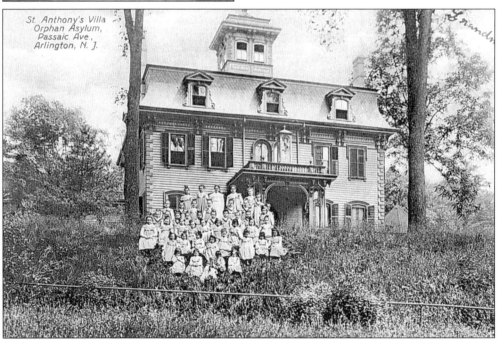

THE ST. ANTHONY'S VILLA ORPHAN ASYLUM. This orphanage, controlled by the Missionary Sisters of the Sacred Heart, occupied the former estate of a Mr. Edwards on Passaic Avenue. It later became a Montessori school. (Courtesy of Norman Prestup.)

80

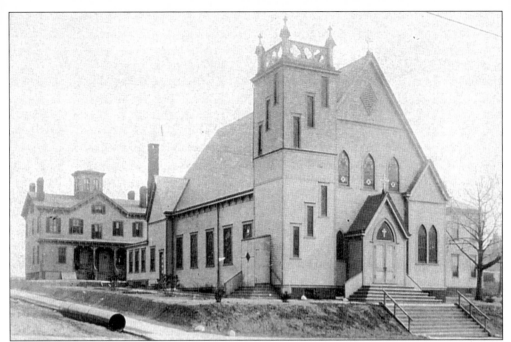

KEARNY'S FIRST ROMAN CATHOLIC CHURCH. Before the erection of St. Cecelia's, the town's first Catholic church, worshippers had to attend mass at Holy Cross in Harrison or at a church in Newark. In September 1893, Bishop Wigger announced the decision to create the parish of St. Cecelia's for Kearny's Catholic residents. The church, purchased for $8,000 and built on the site of the old Jerolemon homestead on the corner of Kearny Avenue and Duke Street, was dedicated to service in 1894. The cornerstone was laid in 1895. (Courtesy of Norman Prestup.)

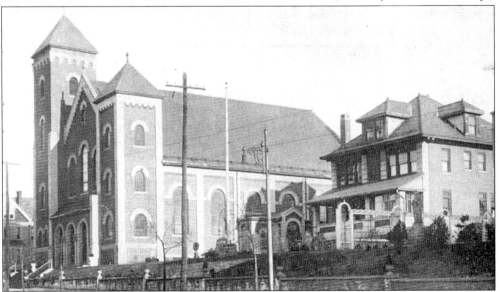

ST. CECELIA'S OCCUPIES NEW BUILDINGS, ERECTED IN 1922. Father Conroy helped the parish effect the construction of this church. Monsignor Kernan had purchased the ground and the new building, including schools, the rectory, and shrines. They were erected on the site of the first St. Cecelia's. (Courtesy of Norman Prestup.)

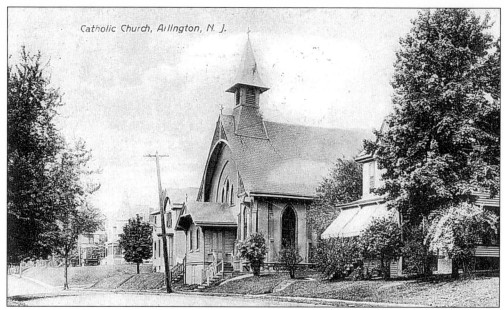

Catholic Church, Arlington, N. J.

THE ORIGINAL ST. STEPHEN'S. As the town's Catholic population increased, the pastor of St. Cecelia's purchased a Methodist church on Chestnut Street and converted it into a mission chapel. Within a few years though, the mission was designated as a parish of its own, and so St. Stephen's Church was born. This first St. Stephen's structure, located at Midland Avenue and Chestnut Street, was built in 1904. It was replaced in 1915 with a new structure on the same site, which was ultimately converted to a school exclusively when the new building was ready in 1939. (Courtesy of Norman Prestup.)

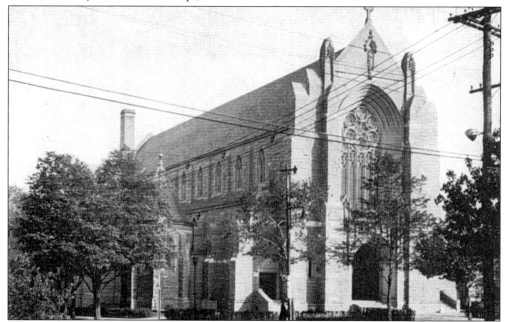

ST. STEPHEN'S. Bursting at the seams in the 1930s, the St. Stephen's parish purchased property at Laurel Avenue. The new church was dedicated in September 1939. (Courtesy of Norman Prestup.)

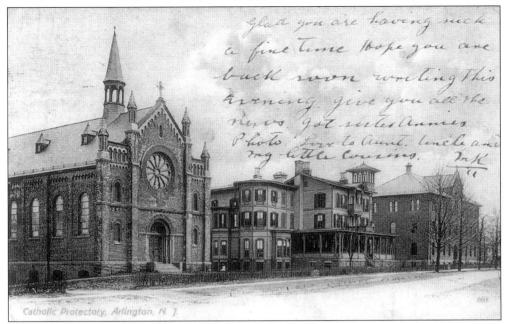

THE BOY'S CATHOLIC PROTECTORY. Built on the former Knapp estate on Belgrove Drive facing Quincy Avenue, the 1902 Gothic-style church, Sacred Heart, was one of the buildings of the Boy's Catholic Protectory. (Courtesy of Norman Prestup.)

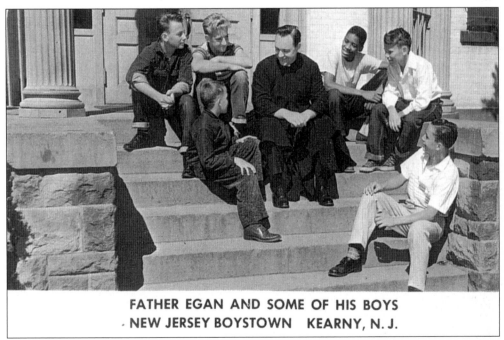

FATHER EGAN, BOYSTOWN. Kearny's Boystown was nearly 80 years old when Monsignor Egan arrived in 1954. Known as the Hudson County Catholic Protectory until 1953, it predated even famous Father Flanagan's Nebraska version. Egan was largely responsible for the modernization of the facility. (Courtesy of Norman Prestup.)

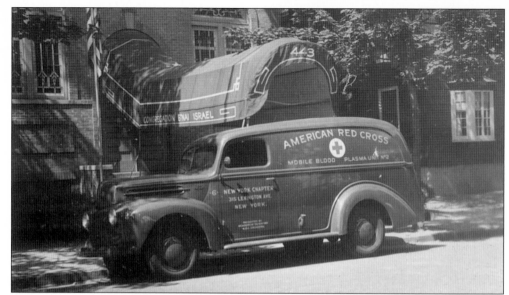

BLOOD DONORS. A blood drive held at Congregation B'nai Israel at 443 Chestnut is the reason why the Red Cross was parked in front of the synagogue's awning. This center of Kearny and North Arlington's Jewish community broke ground in December 1922 and served until it moved to new, larger quarters on Kearny Avenue in 1954. The building was sold to the Salvation Army. (Courtesy of Jewish Historical Society of Metrowest.)

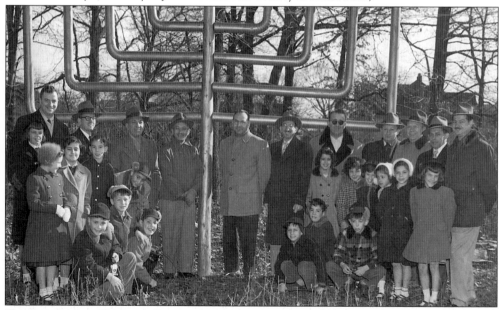

CHANUKKAH IN KEARNY. Congregation B'nai Israel's Rabbi Leon Yagod led the candle-lighting ceremony to celebrate Chanukkah in December 1953 on the site of the new synagogue location at 780 Kearny Avenue between Stuyvesant and Bennett Avenues. Seen standing behind the children of the Hebrew school are, from left to right, Jack Golding, Rabbi Yagod, Al Scheinzeit, Samuel Kraus, Saul J. Abraham, Samuel S. Greenstein, Charles Sussman, Dr. Louis Leviss, Samuel Clott, Dr. Nicholas Keleman, and Dr. Herbert Prestup. (Courtesy of Jewish Historical Society of Metrowest.)

Seven

SCHOOL SPIRIT

KEARNY'S FIRST SCHOOL. The first Kearny school was only one room and was built in 1870 near the east side of Coppermine (now Schuyler) Avenue and Bergen Avenue. (Courtesy of the Kearny Museum.)

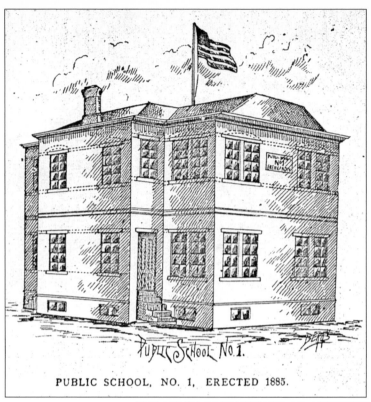

PUBLIC SCHOOL, NO. 1, ERECTED 1885.

THE KEARNY PUBLIC SCHOOL NO. 1. The Kearny Public School No. 1, which was named Franklin School in 1919, was erected on the southwest corner of Schuyler and Bergen Avenues, replacing the 1870 schoolhouse. In 1963, the building was sold to Our Lady of Sorrows Lithuanian Catholic Church for its school, following the completion of the new Franklin School at 100 Davis Avenue in 1960. The Mount Carmel Guild School now occupies the building.

THE KEARNY PUBLIC SCHOOL NO. 2. Built in 1880, the Kearny Public School No. 2, which eventually took the name of the Nathan Hale School, was a brick building located on the northwest corner of Kearny and Johnston Avenues. It replaced the schoolhouse function of the school-town hall-court combination building next to the Knox Presbyterian Church. Students were transferred to the new Washington School, the Kearny Public School No. 2, in 1914.

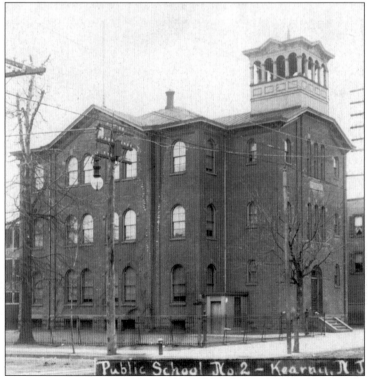

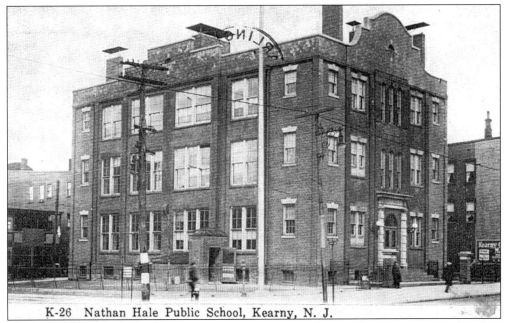

K-26 Nathan Hale Public School, Kearny, N. J.

THE NATHAN HALE SCHOOL. Even after the opening of the Washington School, the Nathan Hale School, looking somewhat more modern, continued to operate. Kearny Motors Incorporated demolished it in 1954 to put up a gas station. A bank now stands on the site. (Courtesy of Norman Prestup.)

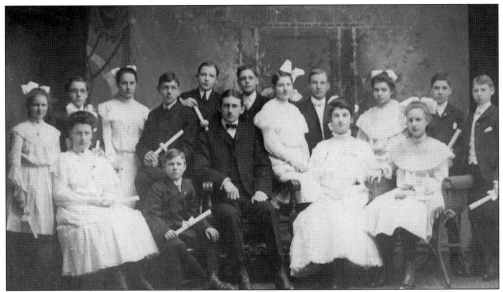

A 1905 GRADUATE CLASS OF SCHOOL NO. 2. Shown here are, from left to right, Ida Bridge, Anna Goldham, Gib Reid, Gladys Harper, Bert Baker, William McBain, Frank MacArthur, Thomas Jefferson Cleason, George Ness, Esther Brokaw, Raymond Fairservice, Rebecca Goldstein, Emma Stevenson, Edna Souter, James Gault, and Daniel Naher. (Courtesy of the Kearny Free Public Library.)

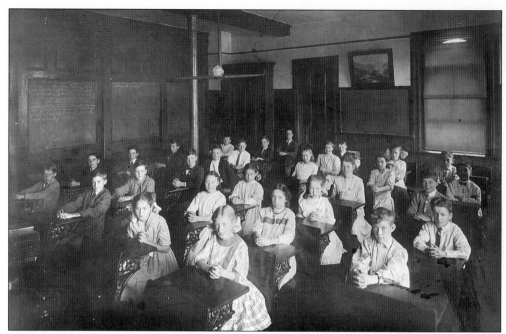

A Class in 1912. This class at the School No. 2 looks somber, as 29 students face the camera in 1912. (Courtesy of the Kearny Free Public Library.)

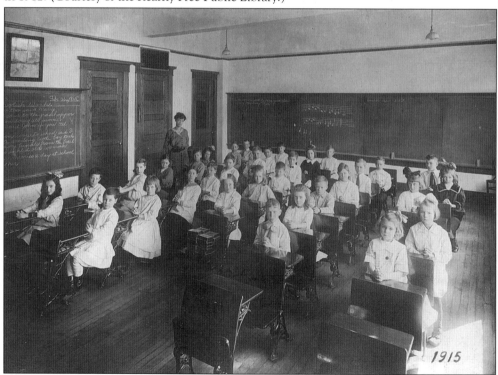

Inside the 1915 Kindergarten Classroom at School No. 2. Not many of today's kindergartners would be able to read the cursive writing on this classroom's blackboards. (Courtesy of the Kearny Free Public Library.)

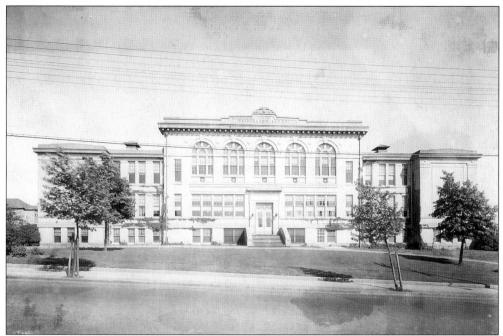

THE WASHINGTON SCHOOL. The Washington School on the corner of Woodland Avenue and Belgrove Drive replaced the Kearny Public School No. 2 in 1914. An addition to the school was made in 1948. (Courtesy of Craig Stewart.)

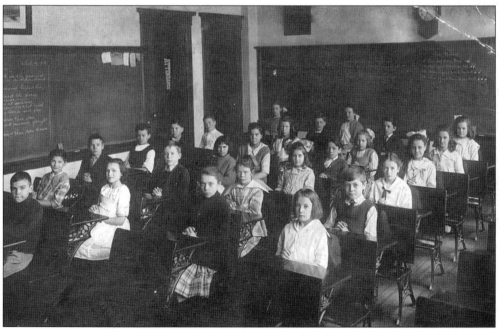

THE WASHINGTON SCHOOL, 1919. A class of seemingly well-behaved children pose for this February 1919 photograph in a Washington School classroom. (Courtesy of the Kearny Free Public Library.)

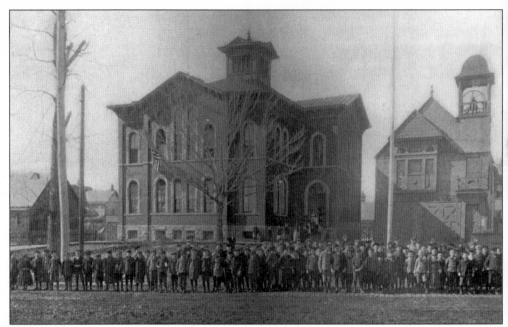

THE KEARNY PUBLIC SCHOOL NO. 3. In June 1875, C.P. Hatch offered to donate a site to the town for a public school at the corner of Midland and Kearny Avenues. In 1879, the Kearny Public School No. 3 was completed, replacing a private school at Midland Avenue and Elm Street. This became known as the original Lincoln School. (Courtesy of the Kearny Museum.)

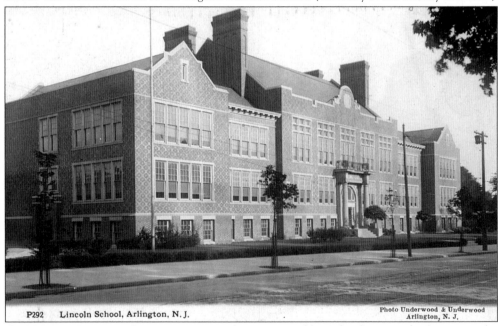

P292 Lincoln School, Arlington, N. J. Photo Underwood & Underwood
 Arlington, N. J.

THE SECOND LINCOLN SCHOOL. In 1909, the Kearny Public School No. 3, also known as the Lincoln School, relocated to the east side of Kearny Avenue near Midland Avenue. Though it received an addition in 1920, the building was demolished in 1965 to make way for the current school buildings, which feature the 1967 John F. Kennedy Natatorium. (Courtesy of the Kearny Museum.)

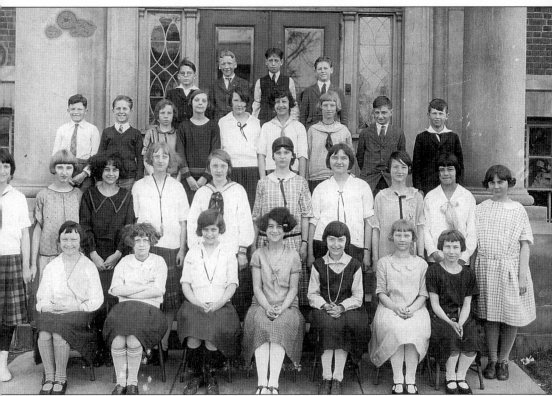

THE EXPERIMENTAL SEVENTH GRADE, LINCOLN SCHOOL. In 1925, a special, experimental seventh-grade class was selected to complete two years of junior high school in one and a half years. Shown here are, from left to right, as follows: (front row) Kathleen Billingham, Virginia Wolff, Edith Parsons, Rose Postman, Frieda Wasserburger, Anna Lawson, and Marion Metzger; (second row) Leona Feinstein, Elfie Hanson, Ethel Georgens, Gertrude Pearson, Louise Presbrey, Josephine Harrison, Eleanor Schlawitz, Annabel Kusanobu, and Katherine Daughtson; (third row) Graeme Turnbull, Gordon Paterson, Lois Brokaw, Helen Hackett, Elizabeth Boan, Evelyn Farina, Lilly Olson, Robert Nicholls, and Charles McCree; (fourth row) Armand Gillespie, Clavin Fisher, Oliver Darling, and Francis Parker. (Courtesy of Clavin Fisher.)

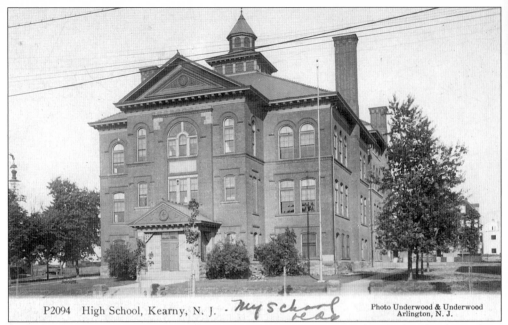

P2094 High School, Kearny, N. J. - *my school years* Photo Underwood & Underwood
 Arlington, N. J.

KEARNY'S FIRST HIGH SCHOOL. Shown here in 1895, Kearny's first high school stood on Kearny Avenue at Halstead Street. Prior to this, students took high school courses in the Kearny Public School No. 2 and No. 3. The first class graduated in 1894, although a full four-year curriculum was not offered until 1897. When students entered the new Devon Street high school in 1923, this school became the Kearny Public School No. 4, the Clara Barton School, which operated as a grammar school until 1932 when it was torn down. Its bricks were used to construct part of the new school's stadium wall.

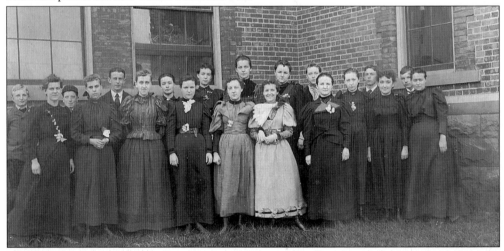

THE FIRST GRADUATING CLASS, SCHOOL NO. 4. The 1894 graduating class underwent a two-year high school curriculum. A three-year course was introduced in 1895. Seen here are, from left to right, as follows: (front row) Cora Colyer, Alice Logan, Lottie McNeil, Dora Canfield, Ethel Cummins, Grace Terry, Ethel Arnot, Sadie Waterfield, Laura Grogan, and the teacher Miss Dashiell; (back row) Fred Buckley, Percy Frazee, Morris Clouse, Belle Turnbull, Florence Latham, Mary Roome, Cora Holmes, Ella Beech, Harry Bird, and Walter Reid. (Courtesy of the Kearny Museum.)

THE LAST WILL AND TESTAMENT OF THE CLASS OF 1907. Notarized by James Kelly, this handwritten document clearly articulates all the things this graduating class bequeathed to its teachers and fellow students. In particular, beware of the watchful eye of Mrs. Eggleston. And to the coming seniors, they leave "our talent for writing compositions, hoping that with a new library at hand, they will come somewhere near our standard." (Courtesy of the Kearny Museum.)

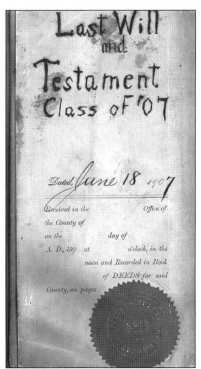

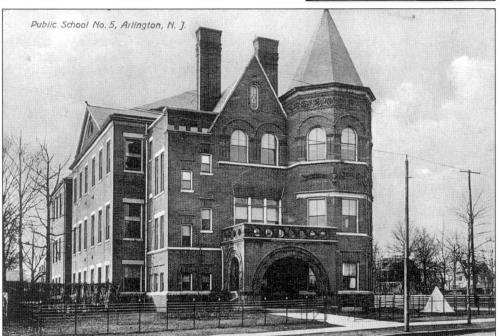

THE KEARNY PUBLIC SCHOOL NO. 5. The first Roosevelt School, known as the Kearny Public School No. 5 until 1919, was located on the same site as its successor, at the corner of Kearny and Stewart Avenues. Built in 1894, it had three stories and ivy-covered red brick walls. Though additions were planned to accommodate the growing population at the north end of town, the school was replaced by the present building in 1936.

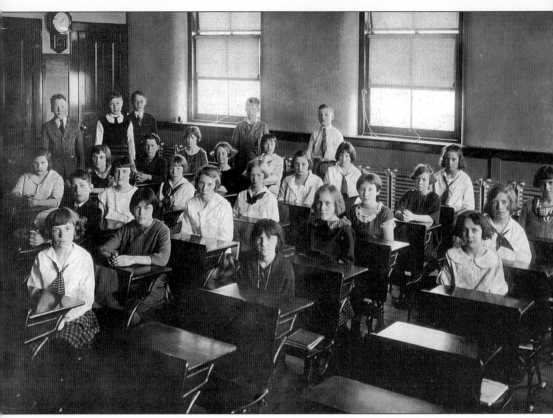

EDITH WHITE'S SIXTH GRADE, ROOSEVELT SCHOOL. The sixth-grade class of teacher Edith White, a 1904 Kearny High School graduate, poses at Roosevelt School in Arlington in 1924. Shown are, from left to right, as follows: (first row) Juliet Cipriano, Alice Anderson, Howard Creed, and Florence Metcalf; (second row) Charles Greidanus, Winifred Lloyd, Lois Brokaw, Almira Keller, and Christina Hirst; (third row) Eleanor Willey, Annabel Kusanobu, Louise Presbrey, Margaret Cameron, Irene Szabo, and Elizabeth Boan; (fourth row) Grace Ramsey, Muriel Aanensen, Elsie Cherwin, Margaret Orrok, and Rose Reicklt; (fifth row) Ethel Georgens, Ruth Tricker, Marion Heddon, and Betty Bradley; (sixth row) Clavin Fisher, Harold Zachias, Edward Bradford, Charles McCree, and Philip Major. (Courtesy of Clavin Fisher.)

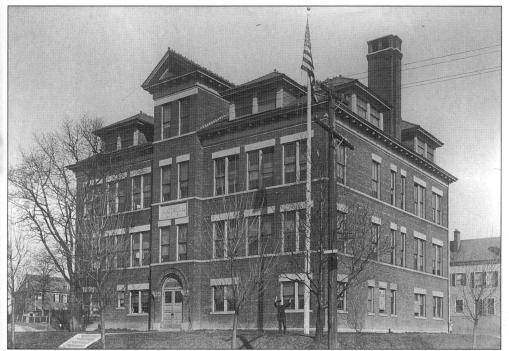

THE KEARNY SCHOOL NO. 6. The Kearny Public School No. 6, the Garfield School, was erected at the corner of Belgrove Drive and Halstead Street in 1901. The original building had eight classrooms on the second and third floors and was the first school in town to boast an assembly room, which was located on the top floor. Additions were built in 1912 and 1929. (Courtesy of the Kearny Museum.)

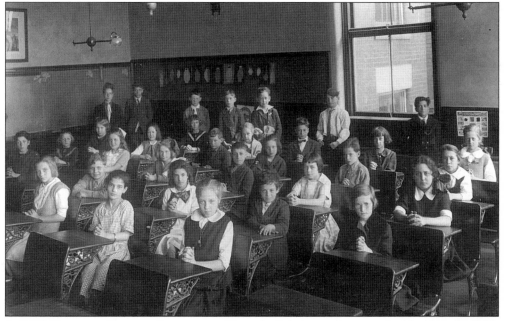

A 1922 GARFIELD SCHOOL CLASSROOM. Three-leafed clovers decorate the blackboards of this fifth-grade classroom. (Courtesy of the Kearny Museum.)

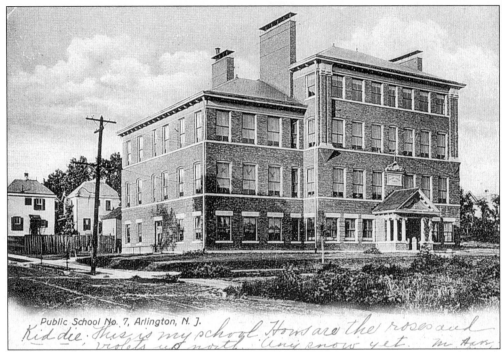

Public School No. 7, Arlington, N. J.

Kiddie. This is my school. How are the roses and violets up north. Any snow yet. M. Aws.

THE KEARNY PUBLIC SCHOOL NO. 7. Also known as Emerson School, this educational facility was built in 1903. It closed in 1963 when the new Lincoln School on Beech Street opened. The building razed, the site stood vacant for many years until the Spruce Terrace senior community complex was erected. (Courtesy of the Kearny Museum.)

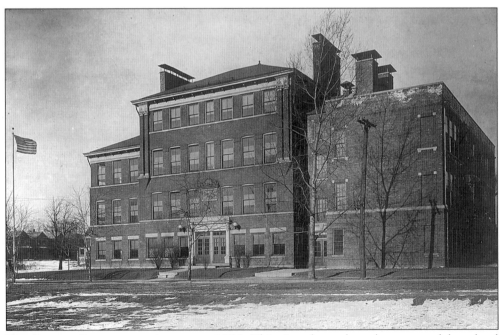

THE SCHOOL RECEIVES AN ADDITION, 1916. This view shows the enlargement of the school to accommodate the children of a growing community. (Courtesy of the Kearny Museum.)

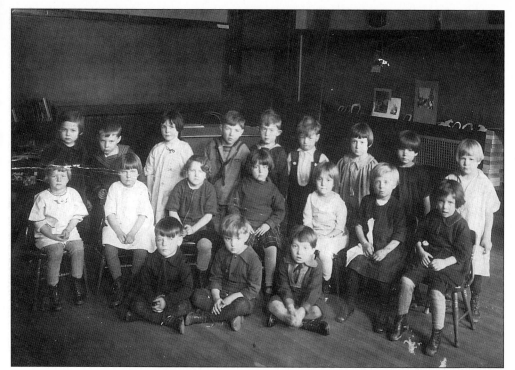

A 1925 KINDERGARTEN AT MCKINLEY. Shown are, from left to right, as follows: (front row) Thomas McMillan, George Rogers, and unidentified; (middle row) two unidentified students, Clara Ragland, unidentified, Florence Rogers, Connie Dewhurst, and unidentified; (back row) Margaret Scott, Donald Montieth, unidentified, Raymond Neale, unidentified, Harold Porter, Margaret Chiariello, Almira Sharrock, and unidentified. (Courtesy of the Kearny Museum.)

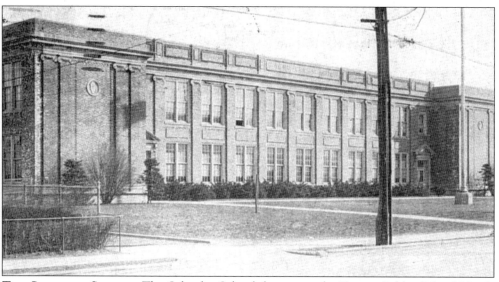

THE SCHUYLER SCHOOL. The Schuyler School, known as the Kearny Public School No. 9, opened in September 1926 on Forest Street to accommodate 760 pupils and to relieve congestion at the Roosevelt, Lincoln, and Emerson Schools. (Courtesy of Norman Prestup.)

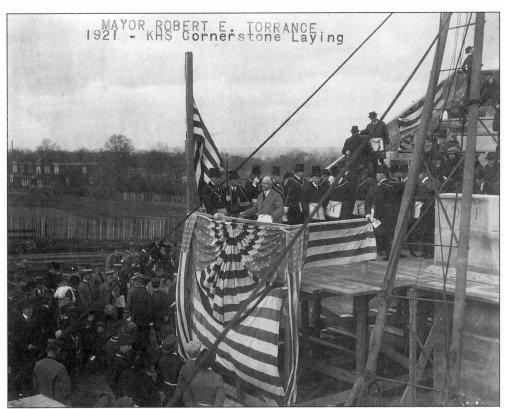

LAYING THE CORNERSTONE OF THE NEW KEARNY HIGH SCHOOL, 1921. Mayor Robert Torrance officiates at the cornerstone ceremony for the new high school on Devon Street. (Courtesy of the Kearny Museum.)

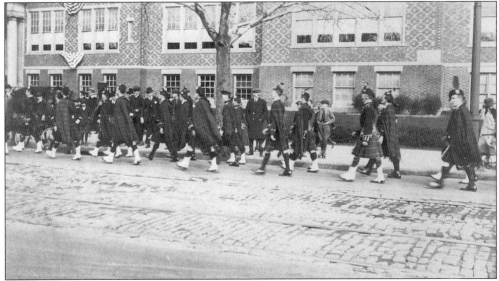

BAGPIPES FOR EVERY OCCASION. Only in Kearny would bagpipes precede a new school dedication ceremony, this one for Kearny High in April 1922. (Courtesy of the Kearny Museum.)

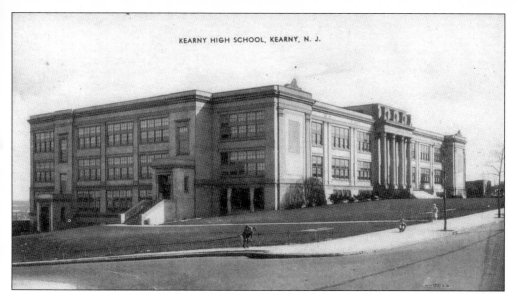

KEARNY HIGH SCHOOL, KEARNY, N. J.

THE KEARNY HIGH SCHOOL. "Dedicated to those who seek knowledge" reads the inscription over the massive portals of Kearny High School at Devon Street, opened in 1922. The school made quite an impression on its first students, who marveled at the broad approach to the building, the four towering pillars, the huge bronze doors, and the long marble corridors. It featured a fully-equipped machine shop, a woodworking shop, a printing shop, two large gymnasiums, a large swimming pool, and a spacious 1,200-seat auditorium. The building is still easily distinguishable across the meadows and can be seen from the New Jersey Turnpike. The north and south stadium walls were built with 300,000 bricks from the Clara Barton School.

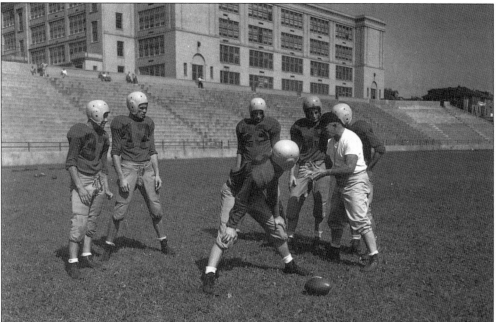

PRACTICE MAKES PERFECT. Coach Art Argauer instructs Bill Kodrowski of the 1949 Kearny High Kardinals. The other Kardinals include, from left to right, Bill Moore, Bill Mitchell, Bill MacPhail, John Watson, and Jack Poland. (Courtesy of Craig Stewart.)

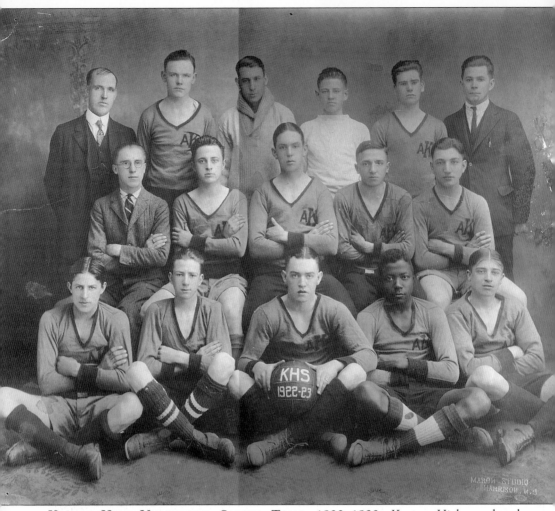

KEARNY HIGH UNDEFEATED SOCCER TEAM, 1922–1923. Kearny High produced an undefeated soccer team in the 1922–23 season, a great way to start in the new school. Coaches were Mr. Young and Mr. Jackson. (Courtesy of the Kearny Museum.)

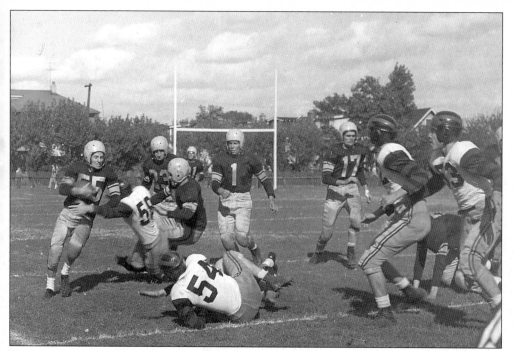

KEARNY LOSES TO COLUMBIA, 1949. The Kardinals have the ball, although they eventually lose to Columbia, 13-12, at this home game on September 24, 1949. Jack Watson carries the pigskin. (Courtesy of Craig Stewart.)

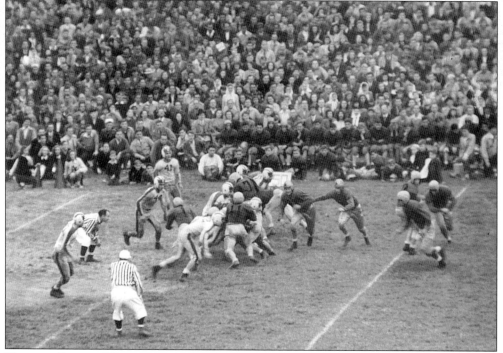

KEARNY BEATS WEEQUAHIC, 1949. The bleachers were packed as Kearny whipped Weequahic, 47-6, in the November 12, 1949 game. (Courtesy of Craig Stewart.)

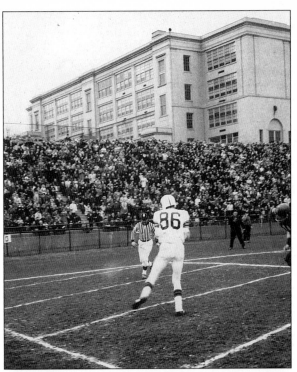

MEL GRIFFIN CATCHES TO PASS, 1968. The crowd looks on as junior Mel Griffin catches to pass in the Kearny-Nutley game on November 28, 1968, marking the first victory against Nutley since 1956. After the game, the goalposts were ripped down in celebration. (Courtesy of Craig Stewart.)

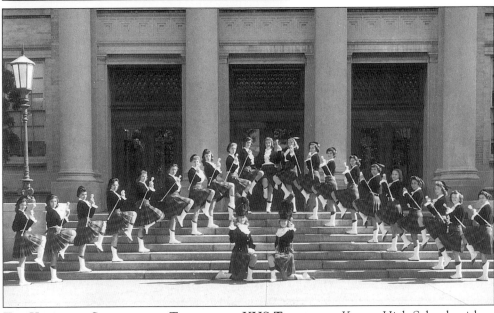

THE KILTS AND SPATS OF THE TWIRLERS, A KHS TRADITION. Kearny High School twirlers, June 1958, wear kilts of the Scottish clan of Bruce. Pictured are, from left to right, the following: (front row) Barbara Sylvester, and Jacqueline Stuart; (back row) Kathleen Healey, Rosanne DePaolo, Christine Juliano, Judith Shaw, Helen Dewar, Clare Dvoranchik, Marian Gaedzinski, Carol McCurrie, Cecilia Podsiad, Mary Blair, Barbara Diamond, Violet Collamore, Beth Schnoll, Marjorie McHugh, RuthAnn Huyler; Jackie Lech, Gayle Pallante, Margie Baier, Virginia Coogan, and Roberta Rogers. (Courtesy of Craig Stewart.)

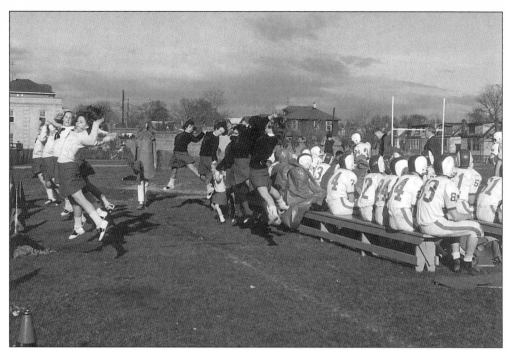

V-I-C-T-O-R-Y. There was plenty of cheering in the bleachers at a 1959 football game. (Courtesy of Craig Stewart.)

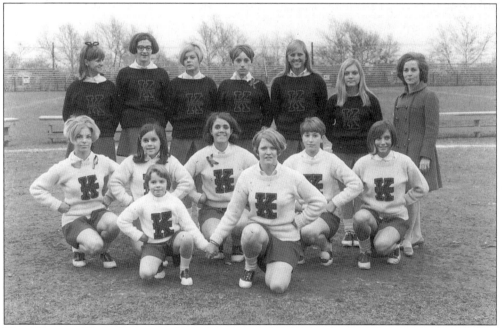

THE KEARNY HIGH VARSITY CHEERLEADERS, 1969. Cheerleaders shown are, from left to right, as follows: (front row) Judy Manley, mascot, and Jan McEwan, captain; (middle row) Diane Farrelly, Janet Manley, Barbara Senna, Maryanne Evanik, and Michelle Caputo; (back row) Michele Fraser, Arlene Danelski, Jeannette Dvarackas, Janet Binder, Debbie Pisiak, Barbara Haberthur, and Kit Cassak, adviser. (Courtesy of Craig Stewart.)

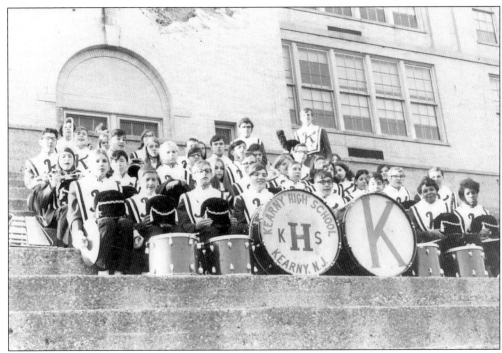

STRIKE UP THE BAND, C. 1970. Standing in the upper right of this photograph of the Kearny High School Marching Band is Charles Kurtzer, drum major, Class of 1971. (Courtesy of Craig Stewart.)

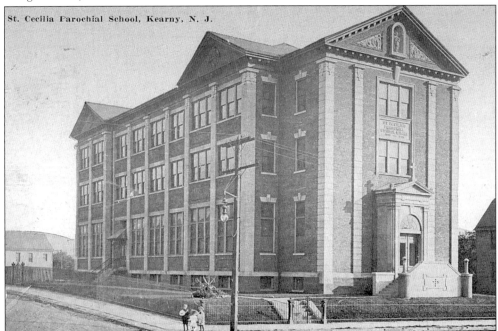

St. Cecilia Parochial School, Kearny, N. J.

ST. CECELIA PAROCHIAL SCHOOL. First established in 1894 on Kearny Avenue near Duke Street, the school moved to Hoyt and Chestnut. Two sisters were in charge when the school first opened; by 1904 there were six sisters instructing 350 students.

Eight
AROUND TOWN

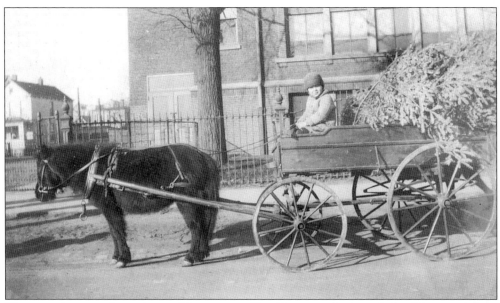

HERMAN GAUCH GETS SOME HELP FROM HIS FRIENDS. Peanuts helps Herman deliver Christmas trees along Schuyler Avenue. The old Franklin School, now the Mount Carmel Guild, is in the background. (Courtesy of Herman Gauch.)

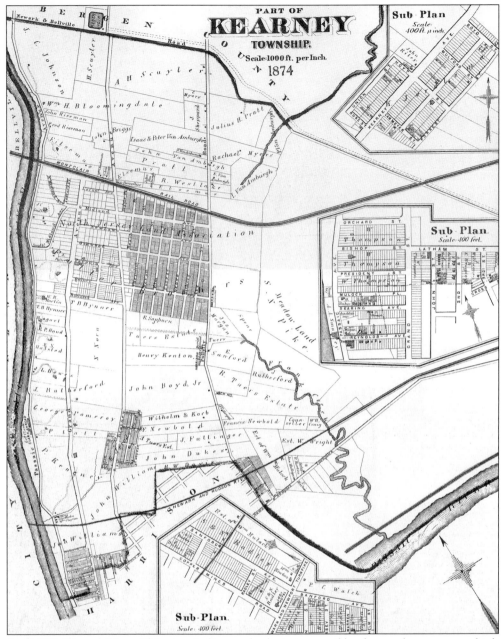

AN 1874 STREET MAP. This map indicates the large tracts of land owned as estates, which eventually came up for multiple-lot development. (Courtesy of the Kearny Museum.)

LAUREL HILL. One of the famous Passaic riverfront estates, Laurel Hill was named after Mr. Laurel, who was one of the earliest settlers in the town. Laurel Hill once boasted a tower, whose stones were eventually used for cellars during the town's growth period. In the 1850s, Henry Gustave Eilshemius purchased the villa with parks, grounds, and drives. His son, controversial artist Louis Michel Eilshemius, was born at Laurel Hill in 1864. (Courtesy of the Kearny Museum.)

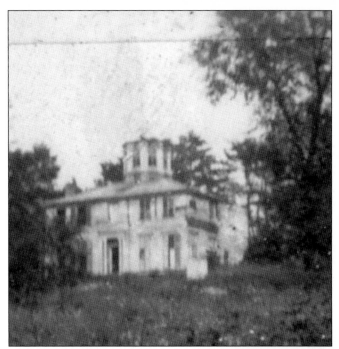

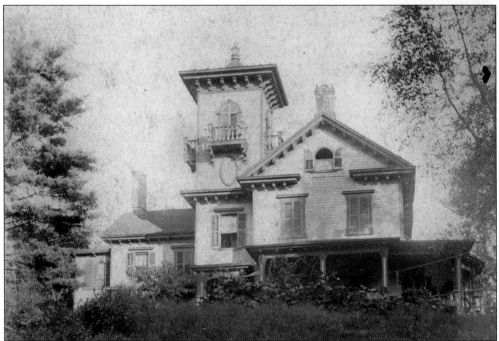

HILLSIDE, THE HALSTEAD ESTATE. Built in 1853, this home of Nathaniel Halstead was considered to be the showplace of the Passaic River estates. Its 40 acres went from the river's edge to beyond the ridge, enclosed by a wall of stonemasonry, which can still be found on the east side of Passaic Avenue north of Hoyt Street. Also on the property were a porter's lodge, a group of barns, henhouses, a corncrib, stables with a repair shop, and farmhand homes. (Courtesy of the Kearny Museum.)

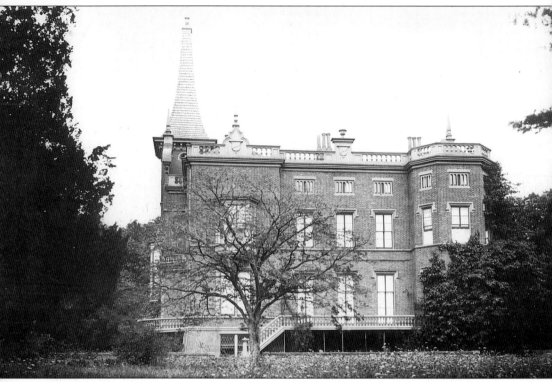

KEARNY CASTLE, BELLE GROVE. Inspired by French architecture, Philip Kearny had this chateau-like red brick residence named Belle Grove built in 1853. He had intended to retire and spend the rest of his life here, but he was killed in battle in 1862. Passaic River captains could see the castle's towering spire, and the home was a stopping place for town visitors. The residence and its sweeping lawns were set back overlooking the Passaic on the road now named Belgrove Drive, known as Grand Avenue in the 1800s, between current-day Patterson and Rose Streets. The property extended all the way to the Passaic. Major General Kearny's descendants lived here for years but by 1926, the home had fallen into semi-decay and disrepair and was torn down to make room for a real estate development. (Courtesy of the Kearny Museum.)

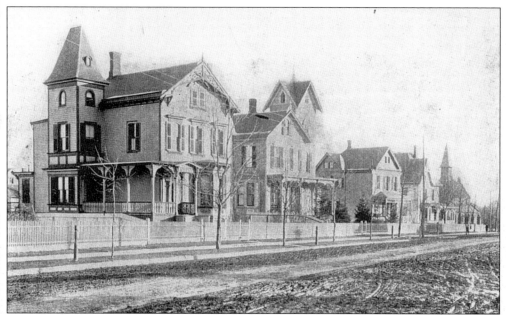

KEARNY AVENUE, C. 1895. In April 1871, the Kearny Township Committee voted on a motion to accept Kearny Avenue, formerly known as Van Emburgh, on behalf of the township and to maintain it. Says the 1895 booklet *Picturesque Arlington*, "On each side of the avenue are many handsome cottages with terraces and flower beds laid out in many different designs, while looking back one sees the sails of vessels on the Hackensack River, and beyond that the tiny houses on Jersey City Heights, and farther off, the towering buildings of New York. On reaching Kearny Avenue one has a treat in pretty, handsome and grand views. The avenue itself, a handsome street, seven and a half miles long, macadamized from end to end, making it one of the best as well as beautiful drives in the country."

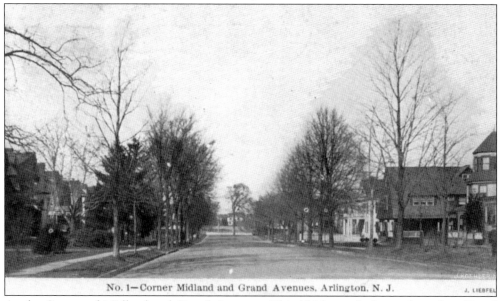

No. 1—Corner Midland and Grand Avenues, Arlington, N. J. J. LIEBFEL

At the Corner of Midland and Grand Avenues. This 1906 view looks northward on Grand Avenue (later Belgrove Drive) from Midland. Many of these fine homes are still here today.

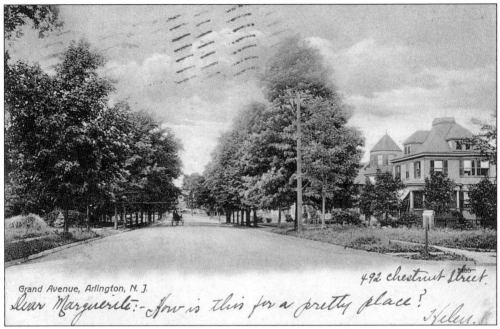

Grand Avenue, Arlington, N. J.

Dear Marguerite:- How is this for a pretty place?

492 chestnut street

Helen.

"HOW IS THIS FOR A PRETTY PLACE?" This is the question posed by a 1907 postcard writer to her Jersey City friend about this Grand Avenue (Belgrove Drive) view.

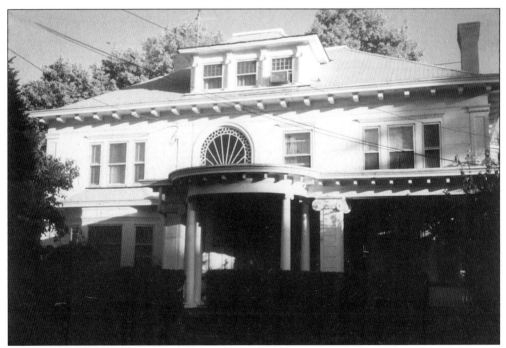

A GEORGIAN BELLE ON BELGROVE DRIVE. The Palladian window above the columned portico and the eave supports beneath the roofline give the mansion classic ambience. (Courtesy of the Kearny Free Public Library.)

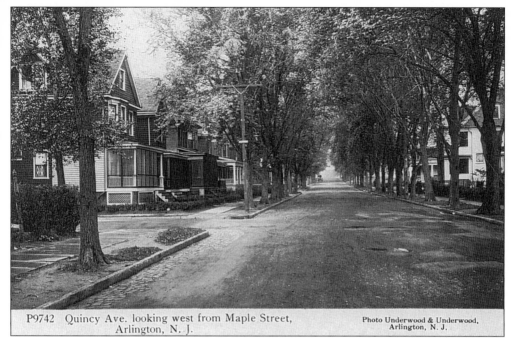

P9742 Quincy Ave. looking west from Maple Street,
Arlington, N. J.

Photo Underwood & Underwood,
Arlington, N. J.

QUINCY AVENUE LOOKING WEST FROM MAPLE STREET. This typical street view shows noticeable wheel tracks from the buggies and carts. The street also features stone borders. (Courtesy of Norman Prestup.)

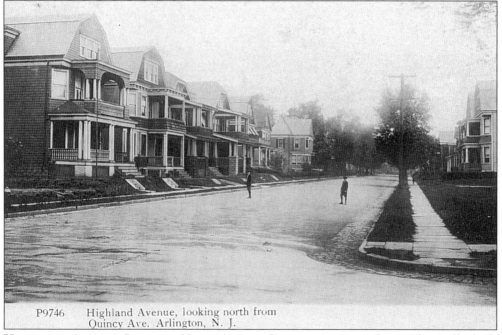

P9746 Highland Avenue, looking north from
Quincy Ave. Arlington, N. J.

HIGHLAND AVENUE LOOKING NORTH FROM QUINCY AVENUE. Some identically built homes mark this street, which has not yet been introduced to a sewerage system. (Courtesy of Norman Prestup.)

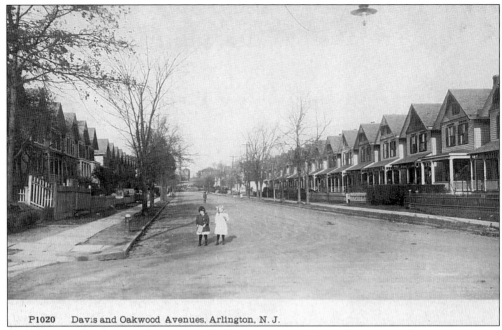

P1020 Davis and Oakwood Avenues, Arlington, N. J.

DAVIS AND OAKWOOD AVENUES. Children pose on Davis Avenue in between rows of identical housing. (Courtesy of Norman Prestup.)

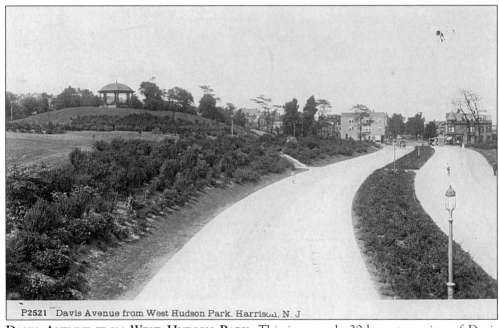

P2521 Davis Avenue from West Hudson Park, Harrison, N. J

DAVIS AVENUE FROM WEST HUDSON PARK. This is an early 20th century view of Davis Avenue from West Hudson Park. Note the horse and buggy in the background. (Courtesy of Norman Prestup.)

112

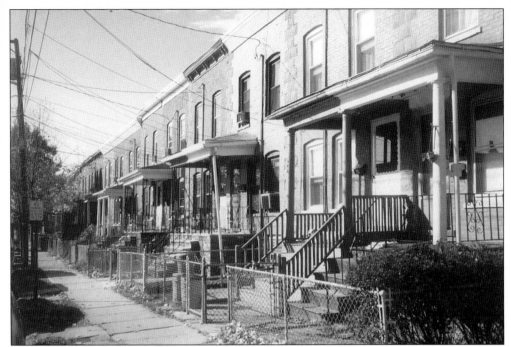

ROW HOUSES. Taken in 1985, this photograph shows row houses, rare in Kearny but almost the earmark of Philadelphia, Baltimore, and even the provincial cities of the British Isles. (Courtesy of the Kearny Free Public Library.)

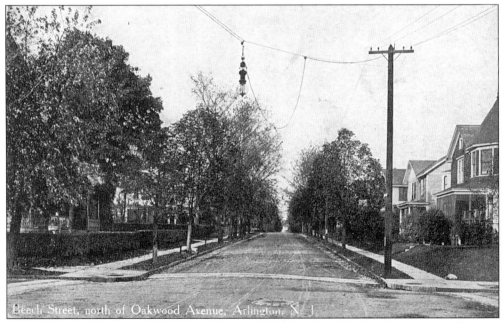

BEECH STREET, NORTH OF OAKWOOD AVENUE. The hanging light, hitching posts, and wagon wheel tracks distinguish this early-20th-century view from scenes of today.

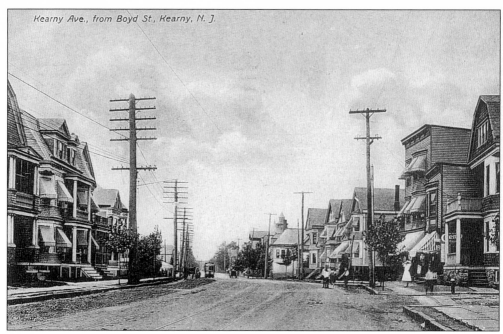

Kearny Ave., from Boyd St., Kearny, N. J.

KEARNY AVENUE FROM BOYD STREET. Wagons and a trolley traverse this stretch of Kearny Avenue. (Courtesy of Norman Prestup.)

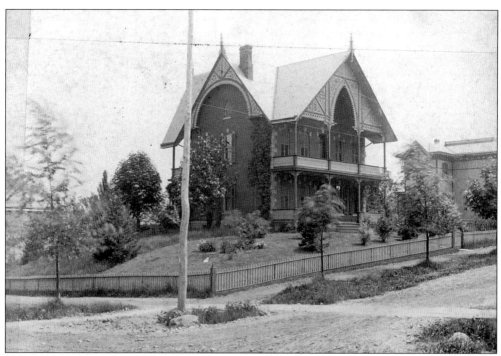

A HOME ON THE SOUTHEAST CORNER OF MIDLAND AND CHESTNUT. This home still stands on the southeast corner of Midland Avenue and Chestnut Street, behind Aanensen's Cabinetmakers. (Courtesy of the Kearny Museum.)

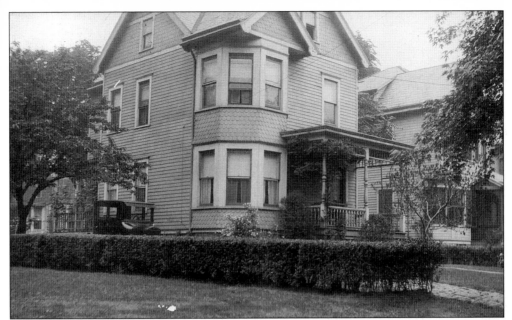

FRANKLIN PLACE HOME. The home of the Pierce family at 11 Franklin Place features a 1928 four-door Packard sedan with a 1935 license plate. (Courtesy of Craig Stewart.)

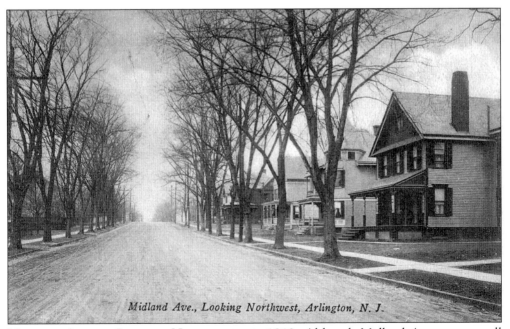

Midland Ave., Looking Northwest, Arlington, N. J.

MIDLAND AVENUE LOOKING NORTHWEST, C. 1912. Although Midland Avenue was well known for its business district, it also boasted some very fine homes.

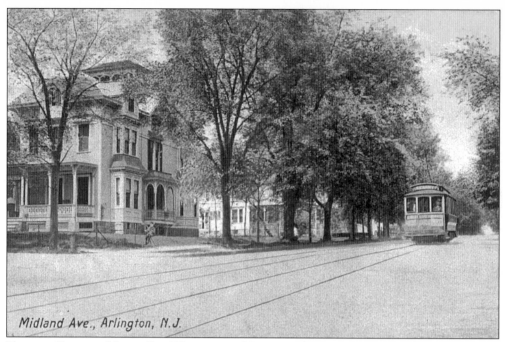

KEARNY TROLLEY MAKES ITS WAY ALONG MIDLAND AVENUE, c. 1909. The once familiar "dinky" transported passengers throughout the area.

A MAN ABOUT TOWN. John W. Jones drives his buggy on Hickory Street and Oakwood Avenue in 1905. The Emerson School, the Kearny Public School No. 6, is on the left. (Courtesy of the Kearny Museum.)

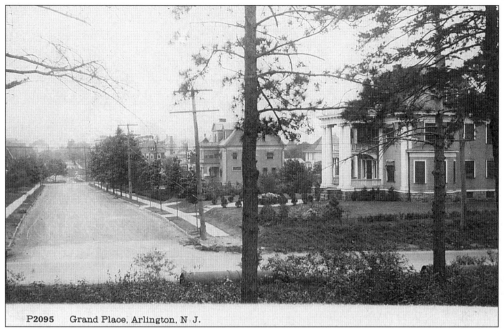

P2095 Grand Place, Arlington, N. J.

A GRAND PLACE. This view was taken looking across the Belleville Turnpike from North Arlington onto Grand Place and one of its equally grand homes. (Courtesy of Norman Prestup.)

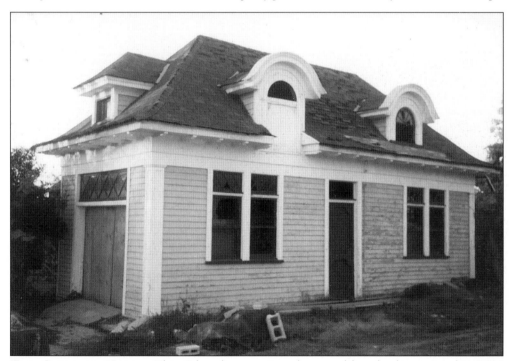

THE CARRIAGE HOUSE. This Edwardian carriage house, although shown in this 1985 photograph in a state of disrepair, stands behind the mansion featured above on the corner of Grand Place and the Belleville Turnpike. It likely served as quarter for coachmen and later chauffeurs. (Courtesy of the Kearny Free Public Library.)

THE CORNER OF STEWART AVENUE AND PLEASANT PLACE, C. 1895. No evidence remains of this lovely, spacious corner of Arlington.

THE HOME OF WILLIAM KILPACK SMITH, C. 1895. This fine home once stood on the site of the Roosevelt School playground on the corner of Stewart and Kearny Avenues.

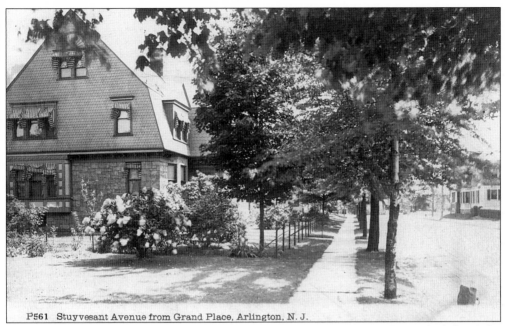

P561 Stuyvesant Avenue from Grand Place, Arlington, N. J.

STUYVESANT AVENUE FROM GRAND PLACE, C. 1916. This home still stands, behind the branch library.

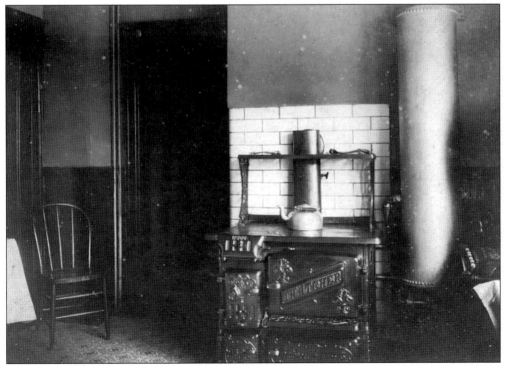

A KEARNY KITCHEN, 1913. This wonderful photograph is an intimate portrait of a Kearny kitchen in 1913. (Courtesy of the Kearny Museum.)

THE ARNHEIM HOME, C. 1895. Yet another Arlington rambling home, this one is on Morgan Place north of Stewart Avenue. Mrs. Charles Arnheim endowed the Stumpf Memorial Hospital's Charles Arnheim Memorial Room, a large single bedroom devoted to members of the Royal Arcanum, Loyal Additional, and Woodmen.

THE HOME OF WILLIAM TOLEN, BRIGHTON AVENUE. This photograph was found among other artifacts in a time capsule, a water-damaged tin box found placed within the walls of the Highland Hose Company. Discovered c. 1995, it is estimated the box was placed between 1918 and 1922. (Courtesy of the Kearny Museum)

WEST HUDSON PARK. West Hudson Park dates to 1888, but Hudson County bonds to purchase land for the park were not approved until the election of November 1902. The park has 40 acres and features Fairy Lake, fed by fresh springs and normal rain runoff. (Courtesy of the Kearny Museum.)

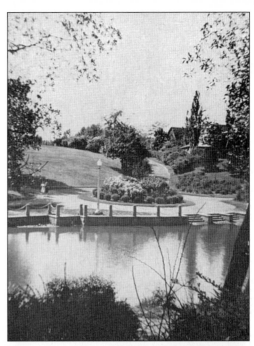

THE WYLIE FAMILY. The Wylie family poses in their Sunday best for this early-1900s photograph taken at West Hudson Park. Developed in 1905, the park had an original purpose "to be a place for relaxation, recreation, and just plain enjoyment of the outdoors." (Courtesy of the Kearny Free Public Library.)

LOUIS AND ALMA GAUCH TAKE A REST, C. 1923. These children sit on a bench at West Hudson Park's Fairy Lake. Duke Street provides the background. (Courtesy of Herman Gauch.)

LILLY HEISCH & COMPANY. Just another day at the Gauch family's dairy farm on Schuyler and Bergen Avenues across from the old School No. 1, the Franklin School. (Courtesy of Herman Gauch.)

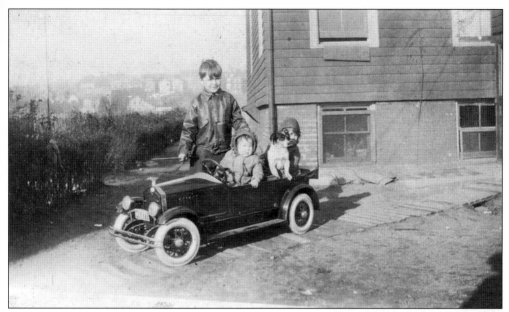

HAVE CAR, WILL TRAVEL. Herman Gauch won this little number in a raffle run by Zalkin's dry goods store. (Courtesy of Herman Gauch.)

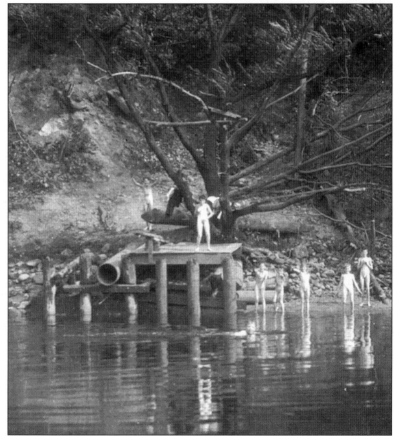

THE OLE' SWIMMIN' HOLE, 1912. Local youths skinny dip in the Ole' Swimmin' Hole at the foot of Laurel Avenue before the Erie Railroad underpass was erected and the grade crossing at the foot of North Midland Avenue was eliminated. (Courtesy of the Kearny Museum.)

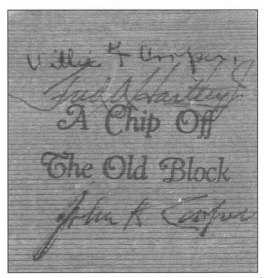

A Chip off the Old Cooper's Block. It was in the early 1880s that a gang of carpenters, a handful of masons, and a few plumbers started assembling board, brick, and pipes at the corner of Johnston and Sheridan Avenues. By midsummer 1885, 55 families, mostly from the British Isles and prospective employees of the Marshall Thread Mill, filled the tenement building. Mr. and Mrs. John Copper owned and operated the ground-floor general store. The tenements were considered to be luxurious homes at the time. The block was razed in 1936. The Kearny Castle Woods provided the playground and the Passaic River the bathtub and washing machine. (Courtesy of the Kearny Free Public Library.)

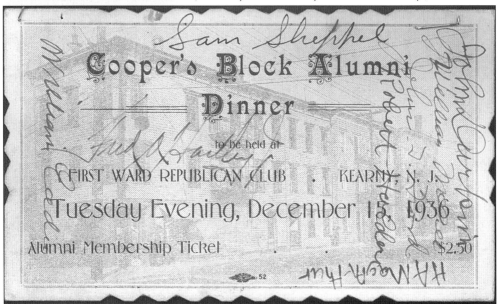

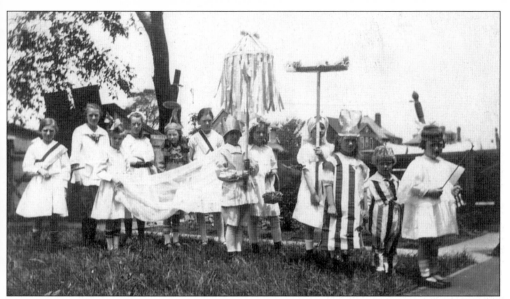

MAY DAY ON BRIGHTON AVENUE, 1920. Maywalks, the traditional May 1 spring festival, included dancing around the maypole, crowning a May queen or arranging a Maywalk with king and queen under a maypole, and a picnic. (Courtesy of the Kearny Museum.)

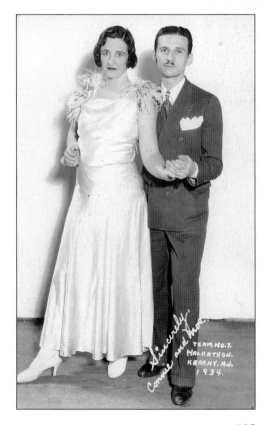

THEY SHOOT HORSES, DON'T THEY?
Looking as fresh as daisies, Team No. 7's Connie and Moe are ready to get started in the 1934 Walkathon in Kearny. Run by David Young, these walkathons, more appropriately known as dance marathons, were held in a building (now Gild-N-Son Manufacturing) at 328 Belleville Turnpike near Beech Street. The infamous Depression-era dance marathons were depicted in the 1969 film *They Shoot Horses, Don't They?*

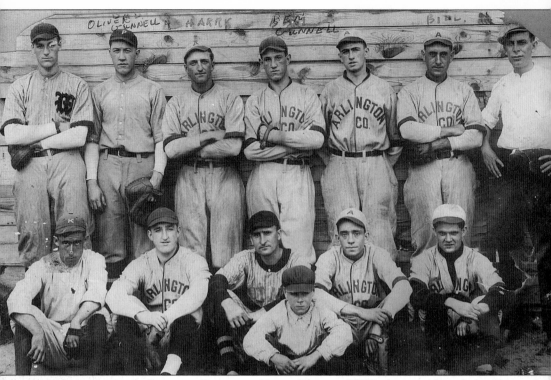

THE ARLINGTON COMPANY BASEBALL TEAM. This pre-WWI photograph includes Benjamin Gunnell (fourth from left in back row) who was killed in action in France in July 1918. The Pyralin Oval off Schuyler Avenue was renamed the Gunnell Oval in his honor. (Courtesy of the Kearny Museum.)

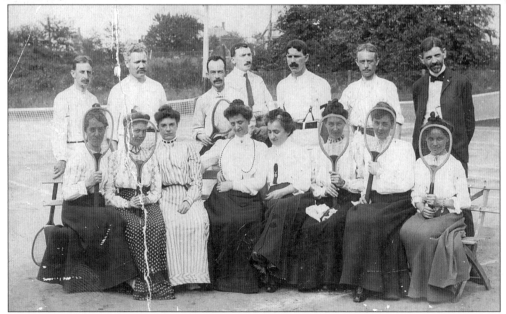

THE TERRACE TENNIS CLUB, JULY 4, 1904. T.R. Cornwall is third from the left in the back row. Laura Cornwall sits third from the left in the front. (Courtesy of the Kearny Museum.)

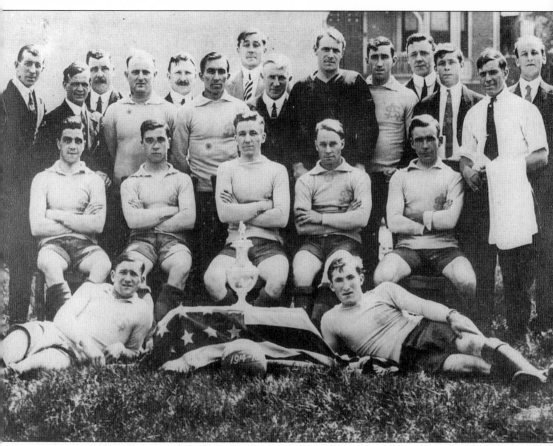

KEARNY, THE CRADLE OF SOCCER. The Scottish Americans, Kearny forerunner of the Scots-American Athletic Club, won the American Football Association Challenge Cup in the 1914–1915 season. It played its home games on Scots Field, more widely known as "the cow flop" at the corner of Central and Passaic Avenues. Fans and players shown are, from left to right, as follows: (front row) forwards John "Rabbit" Hemsley and Robert "Bunt" Forfar; (middle row) halfback Thomas Stark, center Archie Stark; forward Angus Whiston, and halfbacks Eddie Holt and Alex Montieth; (back row) Bob Conn, Medly Purdie, Robert Stark, fullback Mike Toman, Malcolm McMillan, fullback George Rodgers, Jim East, manager Donald McMillan, goalkeeper Joe Knowles, forward Dave Barry, Don Stark, Jack Conlon, trainer Charles Wardell, and Alex Smith. (Courtesy of the Kearny Free Public Library.)

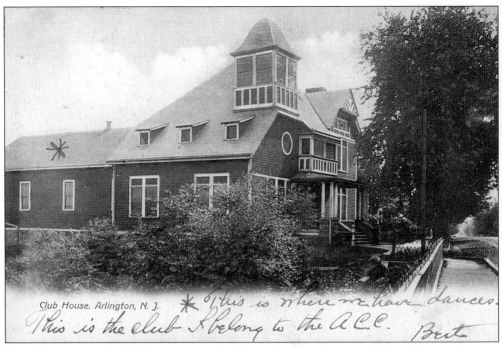

Club House, Arlington, N. J. *This is where we have dances.
This is the club I belong to the A.C.C. Bert

THE CLUBHOUSE. In 1906, this postcard of the Arlington Country Club on Kearny Avenue just south of the Jones Bridge was sent to indicate where dances were held. It is the same building that became the Elks Home, Kearny Lodge, No. 1850 BPOE of Arlington.

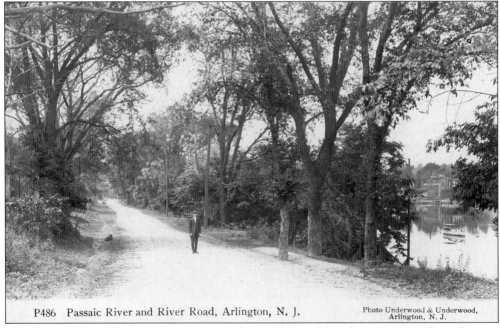

P486 Passaic River and River Road, Arlington, N. J. Photo Underwood & Underwood, Arlington, N. J.

THE PASSAIC RIVER AND RIVER ROAD. Arlington boasted bucolic settings, such as this one along the Passaic River. Note the industrial presence across the river.